7 Keys to Great Paintings

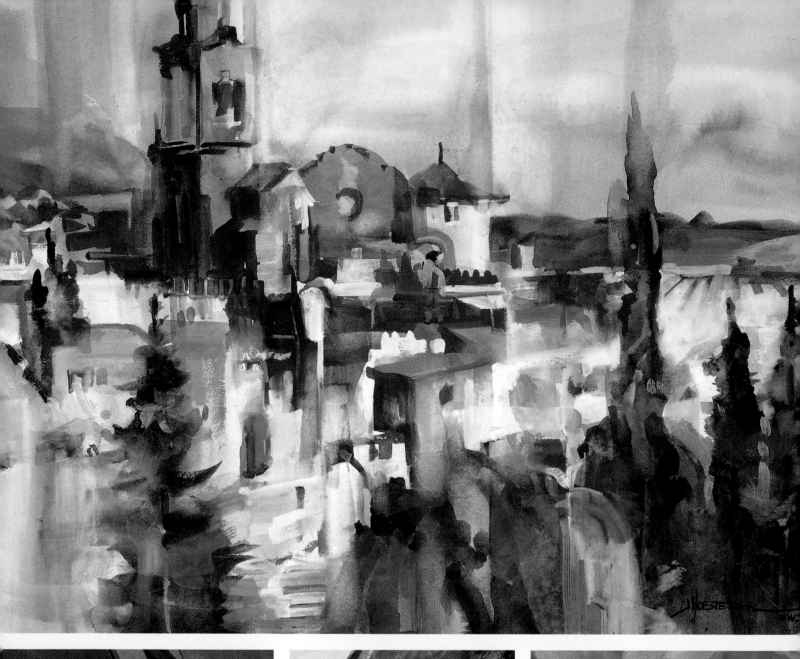

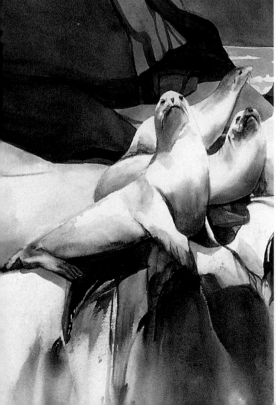

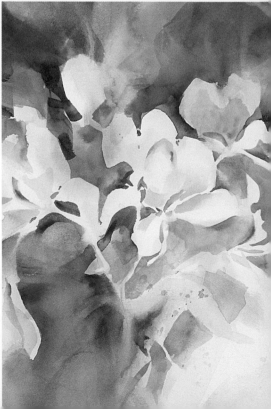

7KEYS
to GREAT
PAINTINGS

Jane R. Hofstetter

NORTH LIGHT BOOKS
CINCINNATI, OHIO
www.artistsnetwork.com

About the Author

Photo by Granville Beale of HomeStudio

Jane R. Hofstetter is a popular workshop instructor who currently teaches watercolor workshops throughout the U.S. and Europe. She has won hundreds of important art awards throughout the years and has enjoyed being a juror for many national art shows. She has been painting and teaching for almost thirty years, and she studied art at the University of California–Berkeley and at the Chouinard Art Institute in Los Angeles. She is an elected and signature member of the National Watercolor Society, Watercolor West, the Transparent Watercolor Society of America and several other national societies. She has painted in over twenty countries, and she recently had a fifty-painting retrospective exhibit at the Triton Museum of Art in Santa Clara, California.

Jane claims that both of her grandmothers helped in ways to kindle her love of painting. When Jane was thirteen, her paternal grandmother, Bessie Robinson, gave her a set of pastels and encouraged her to make portraits of all the family. Jane's maternal grandmother, Elsie Worstell, who had painted in the court of Queen Victoria, eloped with a young American country doctor. Elsie went on to win the gold medal and one hundred dollars for her painting in the Texas Centennial Exhibition in 1898. When the judges learned that a woman had won the award, they wanted it returned, as "women could not paint that well." It wasn't returned, and Jane has the medal today.

Jane's work is represented by Christopher Queen Galleries in northern California. Her work has appeared in many national as well as international art books and magazines, including *International Artist* and *Watercolor Magic* magazines; *The Collected Best of Watercolor* (Rockport Publishers, 2002), *Splash 2* and *Splash 7* (North Light Books, 1993 and 2002), and *Creative Computer Tools for Artists* (Watson-Guptill Publications, 2001).

Other fine North Light Books are available from your local bookstore, art supply store or direct from the publisher.

09 08 07 06 05 5 4 3 2 1

Library of Congress Cataloging in Publication Data
Hofstetter, Jane R.
 7 keys to great paintings / Jane R. Hofstetter.
 p. cm.
 Includes index.
 ISBN 1-58180-479-2 (hc : alk. paper)
 1. Watercolor painting—Technique. I. Title: Seven keys to great paintings. II. Title.

ND2420.H64 2005
751.4--dc22 2004053188

Editor: Stefanie Laufersweiler
Production editor: Mona Michael
Designer: Wendy Dunning
Layout artist: Jessica Schultz
Production coordinator: Mark Griffin

METRIC CONVERSION CHART

To convert	to	multiply by
Inches	Centimeters	2.54
Centimeters	Inches	0.4
Feet	Centimeters	30.5
Centimeters	Feet	0.03
Yards	Meters	0.9
Meters	Yards	1.1
Sq. Inches	Sq. Centimeters	6.45
Sq. Centimeters	Sq. Inches	0.16
Sq. Feet	Sq. Meters	0.09
Sq. Meters	Sq. Feet	10.8
Sq. Yards	Sq. Meters	0.8
Sq. Meters	Sq. Yards	1.2
Pounds	Kilograms	0.45
Kilograms	Pounds	2.2
Ounces	Grams	28.3
Grams	Ounces	0.035

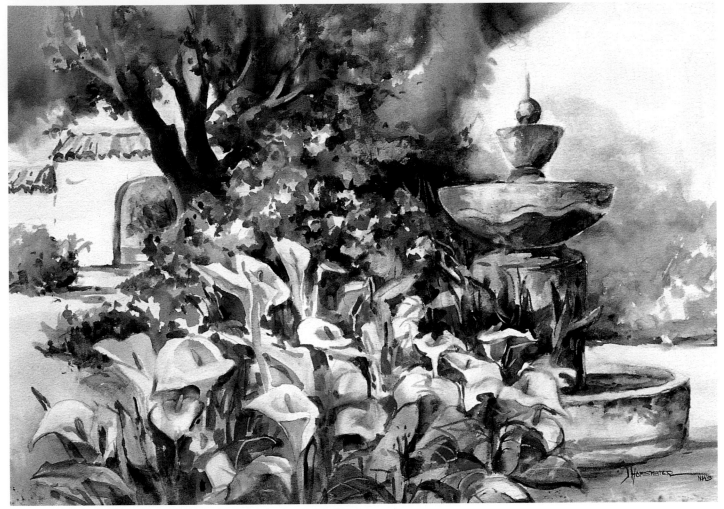

Mission Lilies ~ *Transparent watercolor* ~ *21" x 28" (53cm x 71cm)* ~ *Private collection*

Thank you to

All my students, who over the years have taught me so much about art and beauty.

So many of my friends and fellow artists who encouraged me in writing
this book, among them Carina Hopkins, Roberta Viscovich, Diane Brandenburg
and members of Allied Artists West.

My many wonderful art teachers, among them Jade Fon, Millard Sheets and Gerald Brommer.

North Light Books and my editor, Stefanie Laufersweiler.

My grandmothers, Bessie Robinson and Elsie Worstell, who inspired me
with their love of painting.

Last of all, my wonderful husband, Bill, who even cooks dinner so
I can keep teaching, painting and writing.

Table of Contents

Introduction *page 8*

Watercolor Essentials *page 10*

Conclusion *page 124*

Index *page 126*

1 Pattern

The pattern of value shapes is the skeleton upon which a painting is built. Learn how the sizes and arrangement of light and dark shapes can set up your painting for success from the start. ~ *page 12*

2 Passage

The viewer's eye should travel effortlessly through your painting. Discover how to use a number of passage devices to make connections and transitions among the parts for a stronger whole. ~ *page 26*

3 Focal Area

At the heart of any great painting is a focal area with impact. Find out how to make yours an eye-catcher every time and how to quiet the surrounding areas so that they don't compete for attention. ~ *page 40*

4 Color

Colors create relationships, harmony and emotion in a painting. Understand the many options available to you and how you can manipulate color for maximum results. ~ *page 54*

5 Design

Organize the keys you have learned so far and combine them with powerful arrangement tools—the elements and principles of design—to discover what really makes a painting work. ~ *page 76*

6 The Golden Mean

Part of strong composition is division of space that pleases the eye. Use an age-old ratio to attractively break up the space in any painting, regardless of subject. ~ *page 98*

7 Emotional Depth

The most powerful paintings—those that will be remembered forever by the viewer—combine skillful technique and design fundamentals with the artist's emotion toward the subject. Learn how to interpret your subject and how to channel your feelings to create better, more meaningful paintings. ~ *page 108*

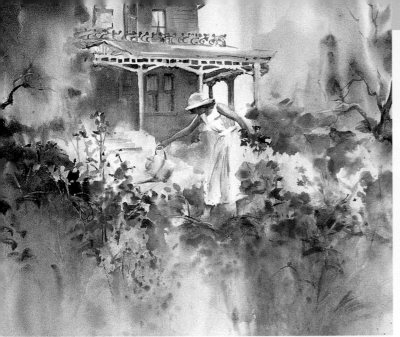

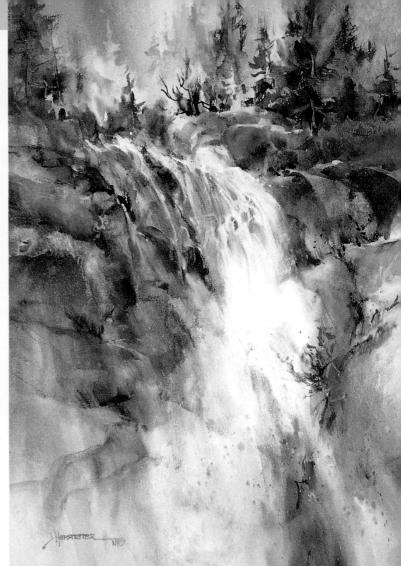

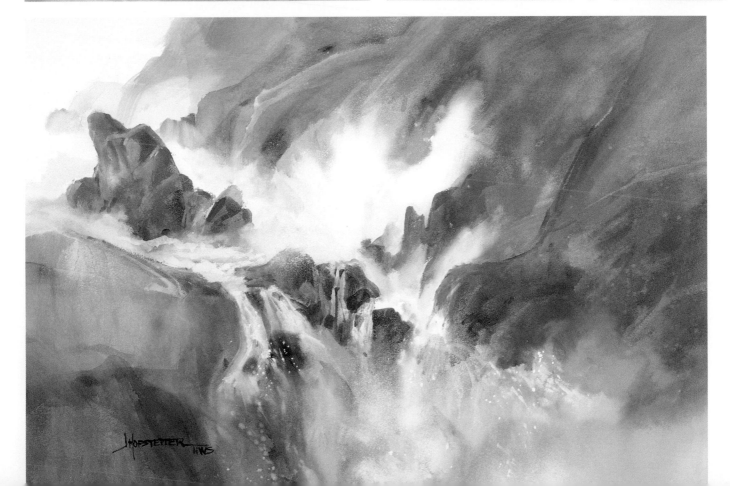

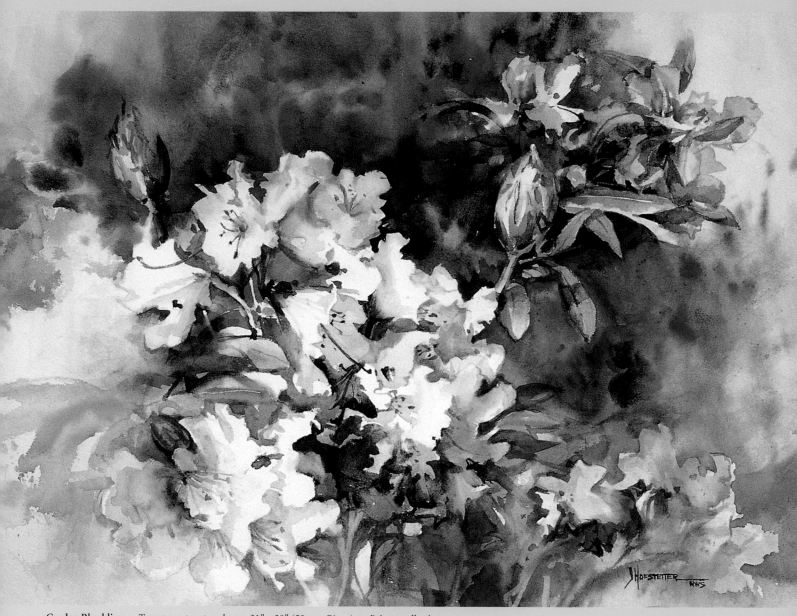

Garden Rhoddies ~ *Transparent watercolor* ~ *21" x 28" (53cm x 71cm)* ~ *Private collection*

Introduction

A few years ago I wrote a poem for my painting students. Each stanza focused on a particular component or key necessary in the creation of great art. A great painting, as I told them, is an eye-pleasing one that is unlikely to be forgotten by anyone who sees it.

I was teaching students who had some past painting experience but acknowledged that their work was in need of some fundamental design improvements. They were not interested in just creating "pleasant" paintings; instead, they told me, they wanted to create stronger works of "soaring visual poetry." I could understand this, as I had also once sought this kind of instruction.

North Light Books invited me to author an instructional art book based on my poem, using a different stanza to introduce each chapter. This became an excellent opportunity to pass on to more emerging artists some of the information and feedback gathered in my almost thirty years of teaching and painting. I wrote the poem to better simplify some of the information that the students wanted to learn.

Life is too short to learn painting only by trial and error. I was so fortunate to have many wonderful art teachers to guide and inspire me, and in this book I pass on many of their words and ideas along with mine.

I have tried to relate each chapter's information on painting to various parts of the human anatomy in the hope that it will make the knowledge stick in your mind better. The miracle of the human body and how each of its systems works is no accident but a deliberate plan. With an equally deliberate plan, we can create masterful, memorable works of art.

Value patterns of light and dark can be likened to the bone structure; eye passage, to circulation; the focal area, to the heart; color, to the skin; design, to the brain; the Golden Mean, to the similar ratios found within human bodies. Finally, emotional depth relates to the human soul. All of this is beautifully expressed in great art.

Most people are able to view art and receive strong, authentic impressions of like or dislike. Often these impressions are hard to articulate. Each of us has a need to relate to beauty, yet beauty is hard to define; what is beautiful to one is not always so to another. My idea of what beauty is came forth from my own eye's experiences as I wrote this book. I pass on to you with heartfelt good wishes some of the shortcuts that, to me, make up the magic of great painting, and I can only hope our perceptions of beauty will match.

7 KEYS TO GREAT PAINTINGS

As you start your work
These words you'll recall,
Make a **pattern** of shapes
Big, medium and small.

Can you move through
The light shapes, we ask?
Passage that's clear
And not blocked is our task.

Make the **focal area**
One-fourth of the sheet,
Darkest dark, lightest light
Not same shapes that repeat.

Good value shapes
Constant **color** change,
Use the color wheel
But not the whole range.

Irregular shapes that
Have good **design**
Lie under our work
And make it shine.

To please the eye
Use the **Golden Mean**.
The 3:5 ratio
Will often be seen.

Lastly look in your **heart**
And paint what you see,
Then remembered forever
Your painting will be.

—JANE R. HOFSTETTER

Watercolor Essentials

These are my must-haves for painting in watercolor. I've developed preferences for certain brands over time and after trial and error with many different brands. Experiment to discover your own favorites.

Paints

My emphasis is on the use of *transparent* and *permanent* colors. No one brand seems to have a complete set of watercolors meeting both of these requirements, so I use colors from a number of different brands. I have found that certain colors in some brands tend to fade or contain opaque materials which tend to make mud in the early stages of a painting. You should test different pigments to see for yourself.

Here are my choice colors, grouped by brand:

- **Daniel Smith:** Carbazole Violet, Cobalt Teal Blue, Green Gold, Indanthrone Blue, Permanent Brown, Quinacridone Burnt Orange, Quinacridone Coral, Quinacridone Gold, Quinacridone Sienna, Sap Green, Transparent Oxide Brown

- **Da Vinci:** Rose Dore

- **Holbein:** Cobalt Blue Tint, Indian Yellow

- **MaimeriBlu:** Orange Lake

- **Rembrandt:** Blue Green

- **Winsor & Newton:** Cobalt Blue, Cobalt Violet, Permanent Magenta, Permanent Rose, Raw Sienna, Scarlet Lake, Transparent Yellow

- **Any brand:** Cadmium Orange, Cadmium Yellow Light, Manganese Blue

I have two folding palettes: a metal Holbein palette and a large, plastic Dick Blick palette that measures 5½" × 12" (14cm × 30cm) when closed. I fill each well completely and spray the paint with water to keep it moist during the painting process.

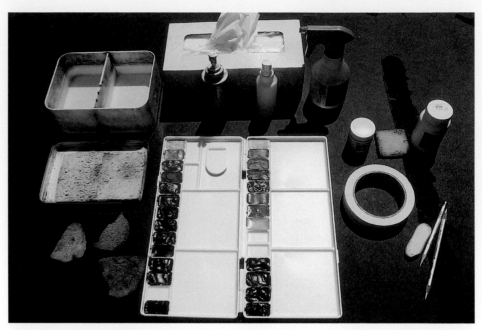

My Watercolor Supplies
Clockwise from left to right: natural elephant-ear sponges; synthetic sponge (with water container); water container; facial tissues; spray bottles (finger action, fine mist and trigger); graphic white; crepe lifter; masking fluid; artist's tape; white plastic eraser; and a silver pencil. The palette shows how I lay out my colors: transparents on the left, opaque and sedimentary colors on the upper right, and earth tone transparents on the lower right. I leave some wells empty for adding more colors or for color mixing. I also fill an extra well on the bottom left with more Quinacridone Gold to use for mixing with my greens.

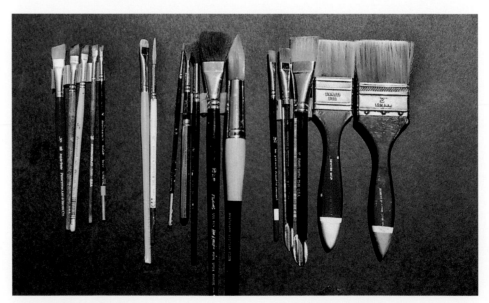

My Favorite Brushes
From left to right: Five angled synthetic flats up to a ½-inch (12mm) in size; a no. 4 bristle oil brush; a no. 5 rigger; nos. 1, 5 and 8 sable rounds; a 1-inch (25mm) flat sable; a jumbo round wash brush; ¼-inch (6mm), ½-inch (12mm) and 1-inch (25mm) flats; and 1½-inch (38mm) and 2-inch (51mm) wash brushes (I prefer Robert Simmons Skyflow). The bristle oil brush is used to soften areas after removing masking, and the rigger is used for line details. Additional rounds can be useful.

Brushes

Synthetic blends are my first choices: They seem to hold enough paint and are sturdy enough to push the paint into wet washes and make it stay in place. Sable is okay; it is useful for a gentle wash over other colors.

I use mostly flat brushes as I paint. The angled synthetic brushes are great for wet-into-wet painting as well as detail work. I use round brushes from time to time, and the size depends on the size of paper or area I am working on. As a rule, use a slightly bigger brush than you think you will need. You can achieve a looser, more painterly look instead of a tight rendering.

Paper

I usually use 300-lb. (640gsm) Winsor & Newton Artists' Watercolor Paper, either rough or cold press. This brand has enough sizing to withstand stencil lifting later in the painting process. I like this weight of paper as I don't have to stretch it before painting and it takes my sprayed water techniques without buckling.

Sponges

Damp sponges serve many purposes; I call them "painting savers." I keep at least three soft, natural elephant-ear sponges on hand to help wet the paper for painting wet into wet, to blend painted areas when needed, to create a soft edge on a shape, or to clean up extra paint or errors without leaving hard edges. I use a few other small, soft, natural sponges for these purposes as well as for lifting paint with stencils. A damp tissue can rough up the paper, but a damp sponge does not. Keep a small kitchen sponge near your water container to blot a brush so it won't carry too much water to the paper.

Water Spray Bottles

I keep three small spray bottles by my side when painting: a trigger bottle to keep palette colors moist, to quickly wash down the paper and to "erase" mistakes before they dry; a fine-mist bottle to keep the paper wet and to provide gentle paint movement; and a finger-action bottle to give an irregular texture on somewhat dry paint. Sometimes I use a finger-action bottle instead of salt for interesting texture.

Other Materials

Additional supplies include:

- Stiff backing board and artist's white acid-free tape for taping paper edges

- Silver pencil (This pencil is lighter than graphite, and the wax in it keeps it from smearing once paint is applied.)

- White plastic eraser

- Two water containers

- Facial tissues and a soft rag

- Hair dryer

- Masking fluid

- Crepe lifter

- Small bar of soap

- Old brushes

- Plastic stencil sheets (for controlled lifting of paint) and small, sharp scissors to cut them with

- Graphic white (I prefer Pro White for the best results when mixing homemade gouache. It is water-soluble and nonpermanent, giving you a second chance to lift back to the white of the paper unlike some white inks and acrylics. Pelikan brand is another suitable option.)

TRANSPARENT COLORS

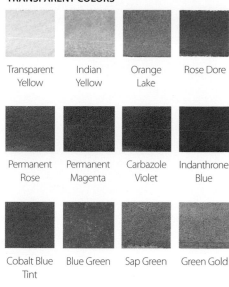

Transparent Yellow · Indian Yellow · Orange Lake · Rose Dore

Permanent Rose · Permanent Magenta · Carbazole Violet · Indanthrone Blue

Cobalt Blue Tint · Blue Green · Sap Green · Green Gold

OPAQUE OR SEDIMENTARY COLORS

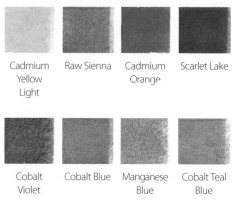

Cadmium Yellow Light · Raw Sienna · Cadmium Orange · Scarlet Lake

Cobalt Violet · Cobalt Blue · Manganese Blue · Cobalt Teal Blue

TRANSPARENT EARTH COLORS

Quinacridone Gold · Quinacridone Sienna · Quinacridone Burnt Orange · Permanent Brown

My Watercolor Palette

These are the colors I use. Additional colors I occasionally use that aren't pictured are Quinacridone Coral and Transparent Oxide Brown. My minimum transparent palette consists of the following ten colors: Cobalt Blue Tint, Indanthrone Blue, Indian Yellow, Orange Lake, Permanent Brown, Permanent Magenta, Permanent Rose, Quinacridone Burnt Orange, Quinacridone Gold and Sap Green.

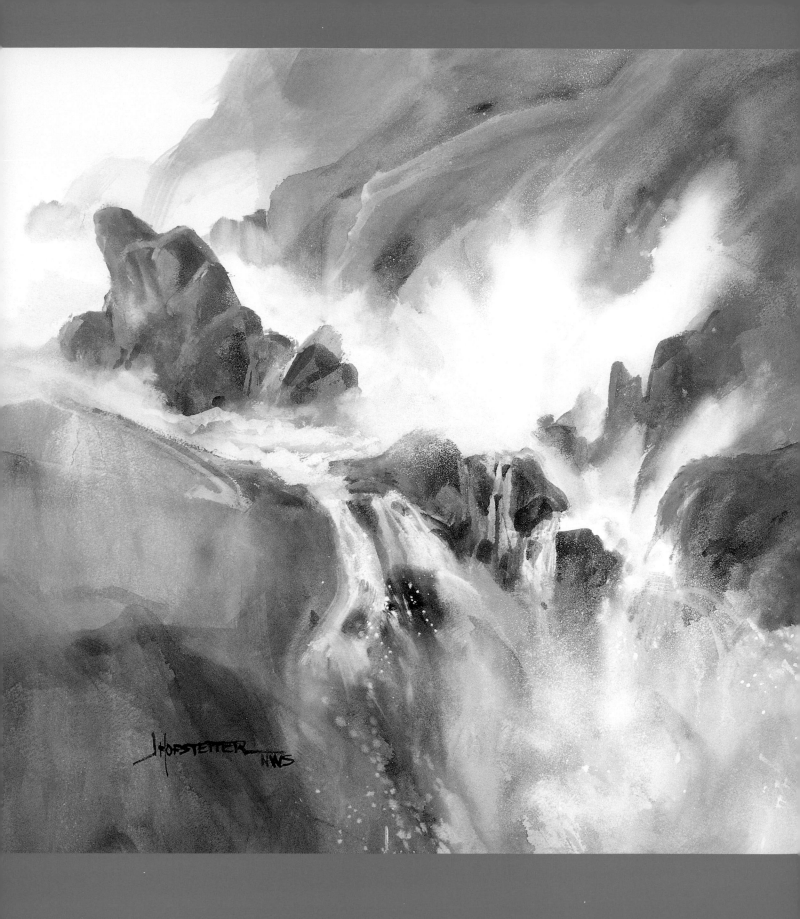

1

Pattern

> *As you start your work*
> *These words you'll recall,*
> *Make a pattern of shapes*
> *Big, medium and small.*

If the basic shapes of a painting are not well designed and exciting, there is little purpose in continuing with the painting. If the basic painting structure bores the eye, no amount of color, texture or detail can save the piece from becoming just another ho-hum painting—pleasant, perhaps, but ultimately forgettable.

Planning the understructure of light and dark shapes at the beginning of each painting is the artist's most important job. This overall pattern of value shapes is the skeleton on which a painting is built. The eye needs this structure to create movement and excitement underneath the subject.

A Pattern That Moves
A moving energy force can entertain the eye with its irregular patterns of value. After sketching the ocean surf on location, I let one of my classes choose a pattern of dark and light from the patterns on page 16. Can you tell which one was used? (See page 16 for the answer.)

Inlet ~ Watercolor with graphic white ~ 21" x 28" (53cm x 71cm) ~ Collection of Janice Swanson

The Best Paintings Have Exciting Shapes of Value

Seeing abstract value patterns, not just the literal subject, is one of the first and most difficult things for a growing artist to learn. Thinking in terms of interesting value shapes when starting a painting is the way to introduce good design before the subject matter even gets drawn. At the design school I attended, this was the first class artists took.

I remember my teacher showing examples of great art to us as we stood across the room. The only things that stood out were value shapes of various sizes, not the subjects themselves. Some of these patterns were so exciting that I wanted to rush up and see what the painting was all about. These were the greatest paintings, I later learned—ones that had endured through the centuries and were revered as masterpieces.

My teacher showed us other paintings that, from a distance, seemed less interesting. These paintings contained value shapes of similar sizes and looked rather like uniform wallpaper. The "magic pull" to move closer to view the patterns didn't happen when the painting's value shapes were similar, predictable and ultimately boring.

WHY THE EYES START WITH VALUE

The eyes are unable to report instantly to the mind everything they see in a painting, so they will move quickly over the simple, large shapes of dark and light first to find a place where smaller, brighter, harder-edged, more irregular complex shapes exist with strong contrast. They continue to return again and again to this intriguing area—the focal area—reporting to the mind what they see. Without this visual excitement, the eyes won't wish to report much information to the mind, and the painting will soon be forgotten.

The Story of a Painting

Emergence began the day I picked a small twig off a berry bush and wondered if I could dramatize the tiny sprig of berries, flowers and leaves into a powerful painting. Selecting a rather rectangular abstract underpainting, which would provide some stability and contrast with the diagonals of the twig, was the first step. I painted the large shapes in transparent watercolor to get the most color glow in the underpattern. Over the dried watercolor, I used acrylics to develop strong darks and create a veiled look. I defined the twig subject with energetic calligraphic brushstrokes. Lastly, I made sure that no piece of the painting was exactly the same as any other.

The finished painting was exhibited in the American Watercolor Society's annual show in New York and was bought on opening night. I was told that the buyer was pulled from across the room to see the shapes better, and upon close inspection of the detail, the painting was even more pleasing.

Emergence ~ *Watercolor and acrylic on illustration board* ~ *21" x 29" (53cm x 74cm)* ~ *Private collection*

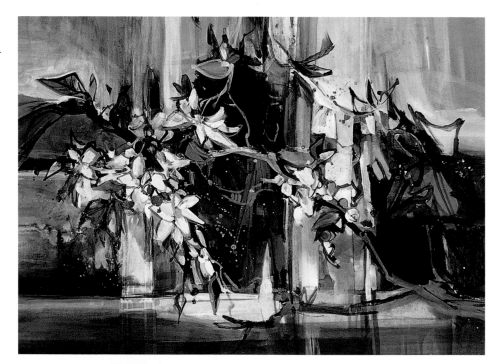

View From Across the Room
Here is *Emergence* out of focus to show only the value pattern as it might look when seen from across a room. I love the saying "A good painter paints with half-closed eyes and a wide-open mind." I squint often as I paint to concentrate on developing those simple but important shapes underneath the painting's detail.

Make Your Own Value-Shape Plans

The lesson my teacher was teaching us about shapes became clear later when I began to work with value patterns myself. A value-shape plan can be used in three different ways:

- You can paint a plan over a design-flawed subject in order to save it.

- You can use it as a preliminary plan before you start to paint—perhaps before you even know what your subject will be—and build the painting's value shapes around the plan as you work.

- You can add your subject on top of a prepainted value plan—a wonderful road map to a well-designed painting as long as you maintain the value shapes underneath.

Any of these ways will work to make the final painting well designed and exciting. I use a tiny thumbnail plan each time I paint. Most of the problems in the original subject get solved here. These plans are so valuable to me that if my house caught fire, my collection of value patterns would be one of the first things I'd carry out!

Practice making value-shape patterns. I use black marker and white correction fluid, but you can also use a pencil if desired. Here are some things to think about as you design value-shape patterns:

- The biggest dark and light shapes usually should be found around the outside edges of the design and should naturally direct the eye toward the more-irregular smaller shapes at the center of interest.

- Avoid perfect geometric shapes. Perfect triangles, circles and rectangles bore the eye, making it skip over these shapes in search of something more irregular and interesting.

- Don't repeat any shape exactly. Vary the sizes and quantities of each shape.

- Avoid equal numbers of light and dark shapes. Let one value dominate in the design to please the eye.

- Change your edges from smooth to broken and irregular in each shape.

- View the final design upside down or on a side to see if the shapes feel balanced. (You may even decide you like the pattern better that way.)

Value-Shape Pattern

A Painted Plan
Paintings with white water are good to work with in the beginning, as you learn to build good shape structures under your work, because the patterns of light and dark are often obvious to the eye. Look for the big, medium and small dark and light shapes. Don't worry about the middle values, as they always show up as you paint and should never be dominant. If the simple dark and light shapes are firmly implanted in your mind or sitting beside you in a thumbnail sketch before you paint, your job as an artist will be much easier.

Surf Play II ~ Transparent watercolor ~ 21" x 28" (53cm x 71cm) ~ Collection of the artist

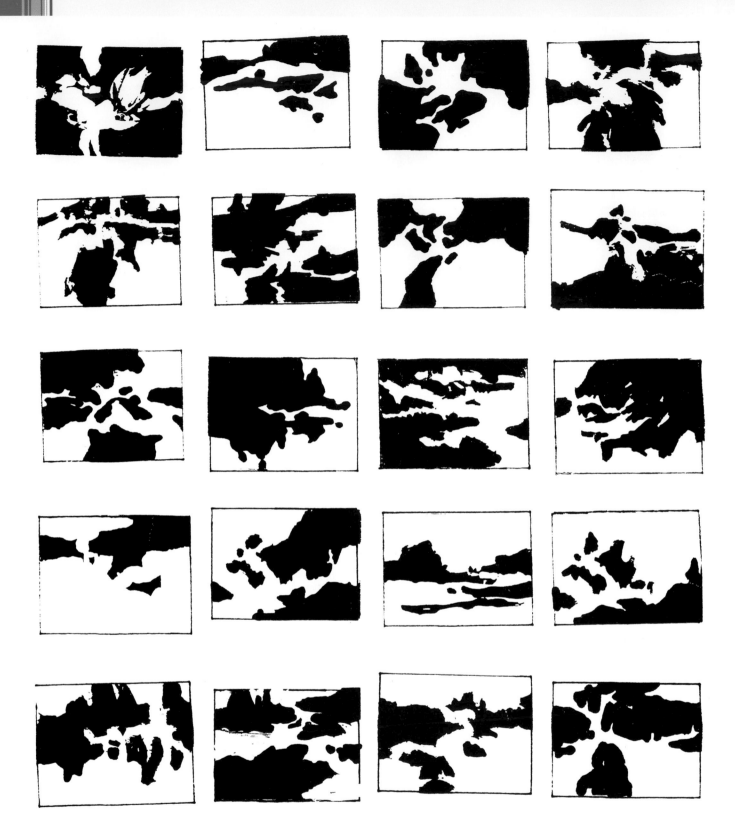

Value-Shape Patterns

Most of my patterns are just quick studies that began when I decided where the big light and dark shapes would be in specific paintings. Good patterns can be used again and again with different subject matter. You can turn them upside down, reverse them and use them horizontally or vertically. (The third pattern in row 1 was used for *Inlet*, the painting on pages 12–13.)

Organize Your Subject Into Eye-Pleasing Value Shapes

When your subject material or reference photo has similar, uninteresting value shapes, *always* change the shapes to make a more exciting design.

Say you are on location painting an outdoor subject, and your painting needs punch. The shadows change all day as the sun moves across the sky. Let the clouds part and send down wonderful, irregular patterns of light and shadow to enrich your subject. The eye will accept any shadow pattern if it is irregular, and therefore beautiful.

Look at your subject's background and surroundings. Are they boring or predictable? By giving it a new presentation or scaffolding of exciting, abstract shapes of dark and light, you will make your subject come alive and be much more exciting to the viewer.

The following examples give some ideas for arranging a subject for the best results.

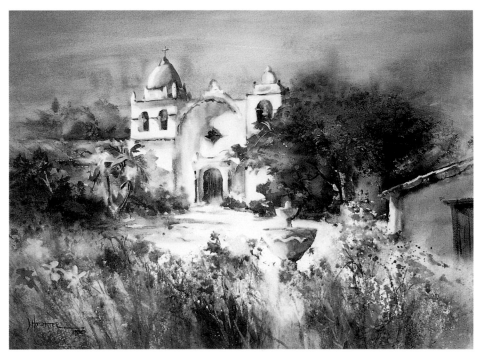

With a light building, surrounding foliage shapes can easily become the dark shapes in the painting.

Carmel Mission ~ *Transparent watercolor* ~ *21" x 28" (53cm x 71cm)* ~ *Private collection*

REVERSE THE PATTERNS YOU LIKE

Making opposites of the thumbnail patterns you like will increase your options. Reverse dark and light shapes as well as their placement. This is not always easy, but if you try it, you will really learn to see shapes. As a result, your drawing skills will grow quickly.

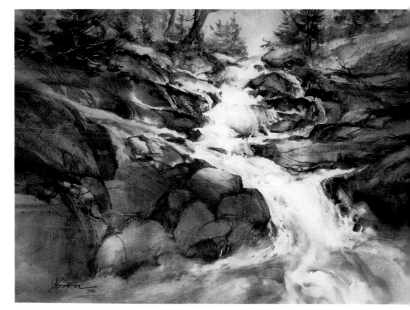

With white water, the surrounding rocks and trees usually become the irregular dark shapes.

Woodland Creek, Summer ~ *Transparent watercolor* ~ *21" x 28" (53cm x 71cm)* ~ *Collection of Kaiser Hospital*

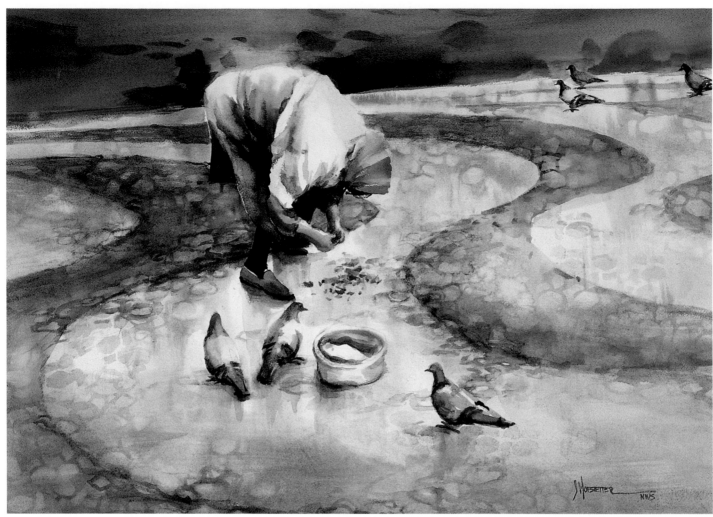

A Different Kind of Pattern

A painting whose values and rhythms of dark and light are already varied does not need a value underpainting. Look at this painting of a lady feeding pigeons. There was much more in the background of the reference photo, but what was important to me in the painting was the circular rhythms of the sidewalk patterns, the round bowl and, above all, how she looked like a bird herself as she fed them. So I kept the painting simple and let the shapes be mostly circular repeats, but each one is a little different to please the eye.

Always look for good eye movement in the lights and darks. The viewer's eye should be able to move through the darks as well as the lights without getting stuck anywhere.

Feeding the Birds ~ *Transparent watercolor* ~ *21" x 29" (53cm x 74cm)* ~ *Private collection*

Keep Prepainted Value Patterns on File

Having some prepainted value patterns on watercolor paper to use in your studio or when traveling is wonderful and time-saving. When painting on location, I love to reach into my portfolio for one such pattern and match it to my subject matter or the mood. Having the first part of the painting already done speeds up the whole process.

If you begin with an underpainting of your value pattern, make the pattern middle value or lighter. Work wet into wet for soft edges, and be careful to leave the white passages or lift them off with a small natural sponge as you proceed. Underpaint some of the same patterns with various color schemes to give yourself a variety of options. I often prepaint sketchbook pages the same way, as it is then easy to superimpose subjects over them.

Sometimes, when I have used up most of my prepainted sheets, I am forced to use an abstract beginning that doesn't seem to match the subject in front of me at all. Often that painting turns out to be the best one, as it is the most unusual and original. Any good abstract value pattern can go under *any* representational subject matter and will most often enhance it.

One Value Plan, Two Different Results

You can achieve vastly different results using the same prepainted pattern. *Grand Opening* uses the underpainting as the basis for a single flower in a warm color scheme, while *Fragrant Ginger* shows a group of flowers in a cool color scheme. This why it's valuable to keep your prepainted patterns and value shape patterns on hand. You can reuse them.

> ### AIM FOR IMPERFECTION
>
> Many flowers appear perfectly symmetrical—whether in reality or in our mind's eye—and cannot become interesting designs until the pattern changes. The more irregular the flower is to begin with, the more pleasing it is to the eye. Draw the petals unevenly. Make each petal a little different in shape from any other one, and try painting shadows over some of the petals. Extend some of the petals to touch one edge of the painting but not the opposite edge. The eye will accept any irregular pattern as long as it is interesting.

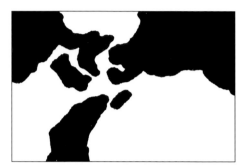

Value-Shape Pattern

Prepainted Pattern

A Single Stunner

One of my classes wanted me to show them how to give a single torch ginger flower lots of variety. First, a middle-value, soft-edged underpainting was created from the value-shape pattern chosen by the students. Then each petal was painted onto or lifted off of the dried underpainting. Not a single petal is the exact duplicate of any other. Collage papers were used along with pearlized paint to soften some areas at the finish.

Grand Opening ~ Watercolor and collage ~ 18" x 24" (46cm x 61cm) ~ Collection of the artist

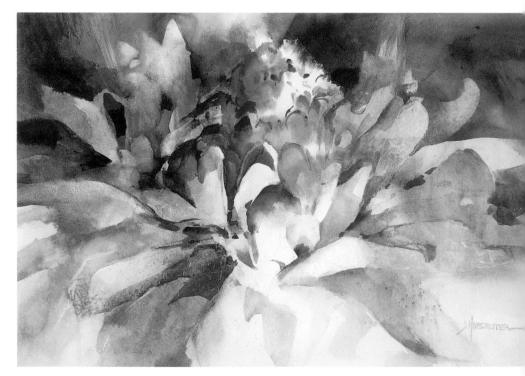

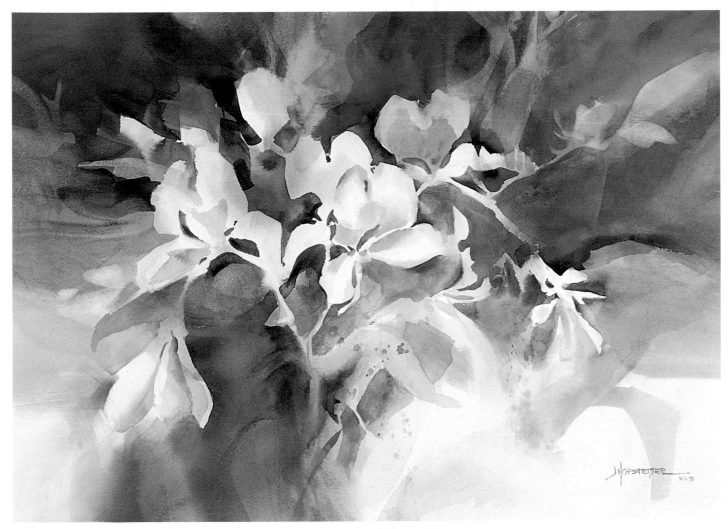

A Group Effort

This painting was created after the same class sketched wild roadside ginger. The students wanted to see the same value pattern applied to a group of flowers. After a drawing was established, a warm-colored, middle-value, soft-edged underpainting of the value pattern was applied. Once the pattern was dry, the pattern was painted again, this time with with darker, cooler color and thicker paint. The pattern was sprayed lightly with water and the painting was slowly turned on the easel, allowing gravity to pull the paint to the outside edges. Each edge was then mopped up and dried quickly with a hair dryer. Only transparent watercolor was used to complete the painting.

Roadside Ginger ~ *Transparent watercolor* ~ *21" x 28" (53cm x 71cm)* ~ *Collection of the artist*

Use Colored Cellophane to See Value Patterns

Try holding a piece of red cellophane against a cool-colored subject or green cellophane against a warm-colored subject to better judge the true values without being distracted by color. This is the finished painting of *Fragrant Ginger* as seen through red cellophane. Sometimes it is easier to see the dark and light values this way—the value pattern becomes recognizable because we concentrate on value shapes not color.

If you want to distinguish the values in a reference photo, using a black-and-white copy of it will make the task easier.

AVOID THE WALLPAPER LOOK *in a* FLORAL PAINTING

MATERIALS

SURFACE
- 300-lb. (640gsm) rough watercolor paper

WATERCOLORS
- **Transparent colors**: Carbazole Violet, Cobalt Blue Tint, Green Gold, Indanthrone Blue, Indian Yellow, Orange Lake, Sap Green
- **Transparent earth colors**: Permanent Brown, Quinacridone Gold, Quinacridone Sienna

BRUSHES
- **Flats**: 1½-inch (38mm), 1-inch (25mm) and ½-inch (12mm)
- **Rounds**: nos. 1 and 6

OTHER
- Silver pencil and white plastic eraser
- Finger-action spray bottle
- Plastic stencil, precut into petal edges
- Elephant-ear sponges

The flower reference photo on this page shows a typical problem of randomly distributed same-size flowers, which tend to look like wallpaper. The flowers are irregular, so let's see what we can do to pull the shapes together in a more eye-pleasing way.

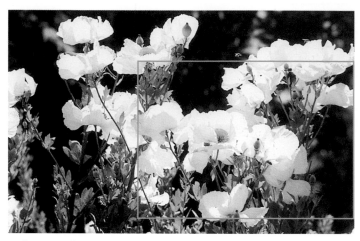

Reference Photo

Simplify; don't try to paint everything in the photo. Let's work only with the isolated section shown. Try to find the big, medium and small light shapes as well as the big, medium and small dark shapes. We know that the smallest shapes of dark and light will become our focal area, so let's try to make them very exciting.

A Possible Value-Shape Plan

Create a black-and-white thumbnail sketch of your big, medium and small shapes to guide you in creating your middle-value underpainting. I chose to make a new pattern that closely fit the subject, but I could have chosen to reuse a pattern from page 16 and rearrange the flowers as needed.

Medium dark shape Medium light shape Big dark shape

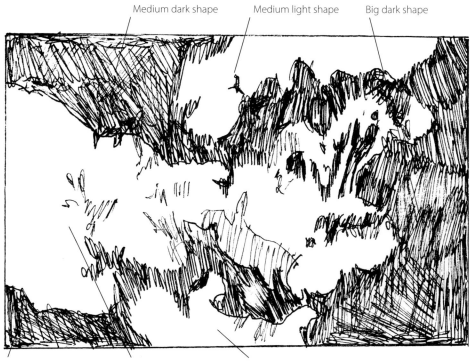

Small dark shape Big light shape Small light shape

1 Make an Underpainting
Choose a color scheme for the painting. (I chose a dominantly cool one with only a few warm accent colors.) Paint the soft-edged pattern from the thumbnail onto your paper wet into wet with your flat brushes, saving the pure white paper as needed for the light areas. Paint it using mainly greens with some blues and violets. Add some yellow-oranges and earth colors for some contrast and excitement. While the paint is still damp, lightly spray some water on it to create interesting texture.

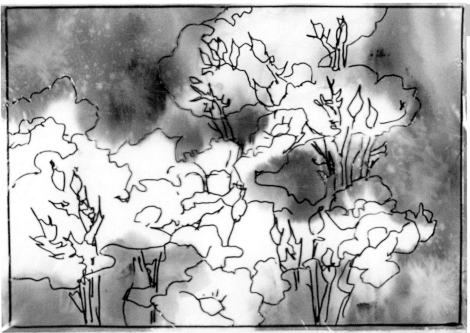

2 Draw Over the Underpainting
Draw the subject on top of the dried underpainting. A silver pencil won't smear, can be erased easily, and isn't as dark as regular graphite pencil. (Since silver pencil wouldn't show up well in a reproduction of this step, I drew the subject on clear plastic with a marking pen to show where I would draw the sketch on the dry pattern.)

WHY I DON'T USE SALT FOR TEXTURE

I used to apply salt for texture in paintings, as many watercolorists do. However, my buyers who live in Florida and Hawaii told me that the humidity caused moisture to gather under the framing glass if salt had been used in my work. I discovered that using a finger-action spray bottle, or any bottle with an irregular spray, gave a more interesting textural effect than salt. I use only water-filled spray bottles for texture now.

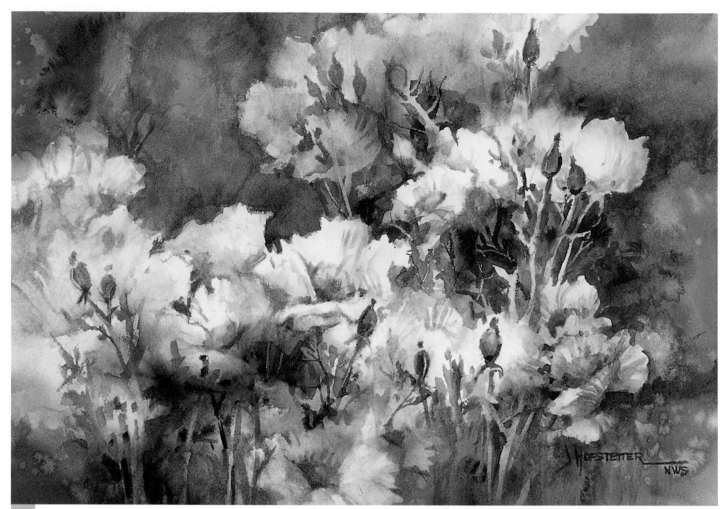

3 Finish by Developing the Details

Finish the painting, making sure to enhance the focal area with the greatest amount of contrast and irregular shapes. Switch to round brushes to paint the smallest details. Change colors often, and soften the shapes as they move toward the paper's edges. Be sure that each value shape has its own unique look and is a different size than the rest. Where the flowers overlap the underpainting, you may want to do some stencil lifting with a damp sponge to recapture the crisp outer edges of the white flowers.

Poppies ~ Transparent watercolor ~ 14" x 20" (36cm x 51cm) ~ Collection of the artist

Focal Area
The smallest, most interesting shapes, along with the strongest contrasts of light and dark, are located in this area.

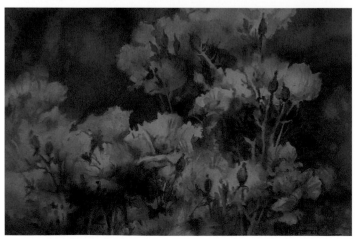

Value Check
Look at the painting through a piece of red cellophane to check your values. The areas of light and dark should be distinct and connect in two overall patterns, with the remaining areas in midtones.

SUMMING UP *Pattern*

You will hear most successful artists and teachers say this over and over: Beneath every representational painting should be a good abstract understructure. The organization of a subject's shapes into a powerful compositional statement is the goal of most artists. Andrew Wyeth calls himself an abstractionist, not a realist, because good, abstract structure must lie under everything he paints.

I could always spot the best future paintings in my classes by the abstract understructure plans the students presented. These early plans are vital! Never begin a painting without a small thumbnail to use as a road map. Make several arrangements and choose the best. It takes only a few minutes and greatly impacts your painting.

Some things you should keep in mind as you create these plans:

- **Place the biggest dark and light shapes first, then follow with the smaller shapes.** Develop the center of interest last; it should always contain the smallest and most irregular of all your shapes.

- **You don't need to plan the middle values.** They will appear during the painting process. Try to memorize only where the darks and lights will be.

- **Vary the types of shapes you use.** If circular or curved shapes make up most of the subject, add a straight edge or two on the shapes to stabilize and anchor the forms as well as provide some variety.

- **Avoid boring geometric shapes.** Even if these perfect shapes exist in your reference, try to make them more irregular and interesting when you sketch them.

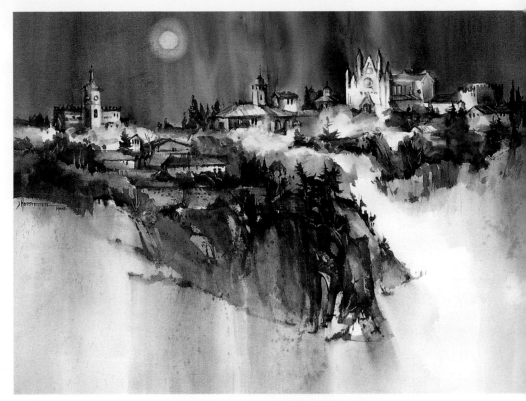

Even Complex Subjects Should Begin With Simple Value-Shape Patterns
Because this landscape scene was fairly detailed, it needed a strong, simple value-shape pattern. The simple shapes provided the best bone structure on which to build. Always look for simple shapes to complement your more complex subject matter.

Moonlight, Orvieto ~ Transparent watercolor ~ 21" x 29" (53cm x 74cm) ~ Private collection

- **Make sure the eye can travel effortlessly through the dark and light shapes.** Don't trap the viewers somewhere in a bull's-eye, a dark surrounded by light.

- **Do not think only of tangible things as your shapes.** Light and shadow falling over and around objects should be included in your shape patterns.

- **Have either the light shapes or the dark shapes dominate.** Equal amounts bore the eye.

- **Watch the edges of your shapes.** Try to give them variety from rough to smooth even in a small thumbnail plan.

- **Remember that eye-pleasing art lies in the simple, irregular patterns of dark and light.** Don't add the frosting (the details) without a good, solid "cake" underneath.

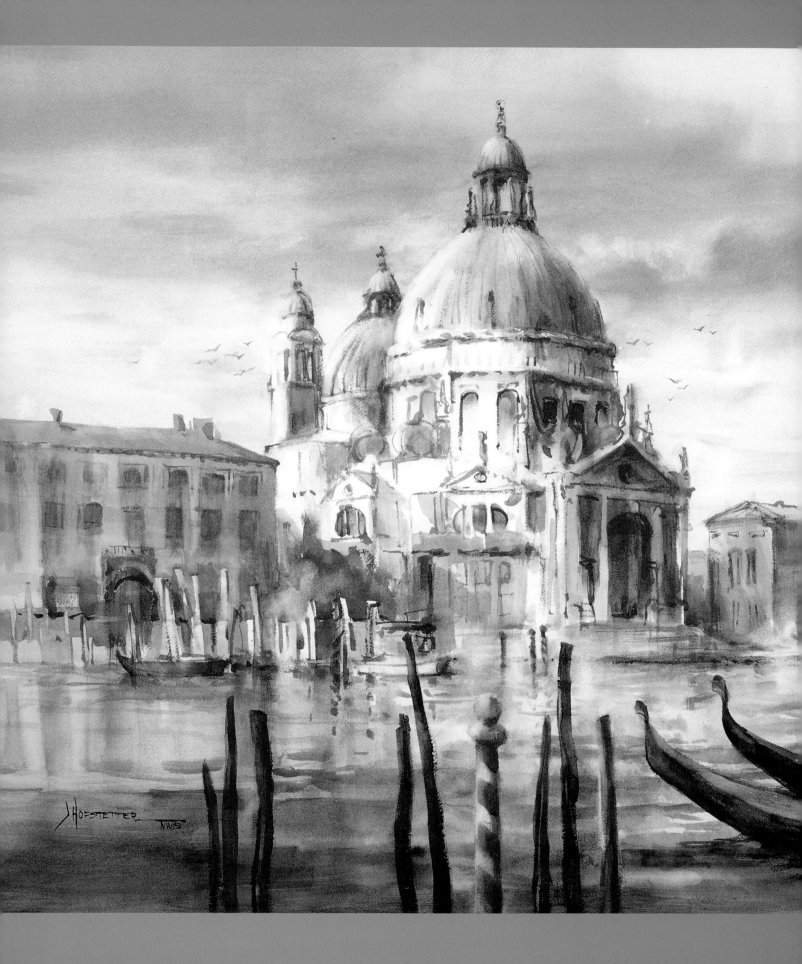

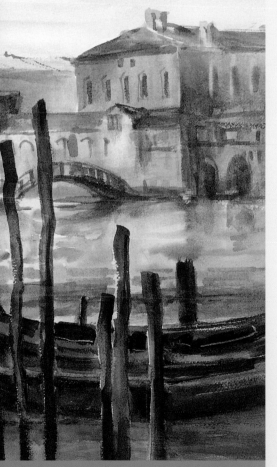

2 *Passage*

Can you move through
The light shapes, we ask?
Passage that's clear
And not blocked is our task.

If pattern is compared to the bones or understructure of a painting, passage can be compared to the flow of the eye through the arteries of a painting. Passage is vital to a work of art. It creates a sense of movement that connects various parts in a rhythmic or comfortable sequence. Without this inviting flow, the viewer's eye must jump around the painting without any directions, connections or transitions to point the way. Many of my students have told me that they have enjoyed certain works of art but never knew why until they studied passage and learned how it can please the eye.

Connecting a Scene With an Overall Wash of Color

For good passage, everything should seem to flow and belong together. In this painting, early morning light washes everything with a rosy glow that brings a beautiful connection to the whole scene. This helps the eye to comfortably move through the overlapping shapes and related passages of this lovely place.

The Grand Canal ~ Transparent watercolor ~ 21" x 29" (53cm x 74cm) ~ Collection of the artist

Direct the Eye With Harmony

When a painting is harmonious it invites the eye to move comfortably through it. There are no divorces taking place among its parts; the idea behind the overall painting is expressed throughout each part. Harmony is a subtle hint of sameness in each piece, which makes each piece belong to the whole.

One important thing to remember is that things in harmony in a painting may be similar in appearance, *but* nothing should ever be duplicated exactly. The viewer would see this at once and be quickly bored.

Good passage in a painting takes a bit of planning before any paint goes on the paper. Yellow against red may look harsh without some yellow-orange, orange or red-orange in between. Midtones are necessary to create transitions and connections among the light and dark values of a painting.

The goal is to create a harmonious transition from one part of the painting to another without making the viewer feel trapped, lost or bored along the way. Try the following passage exercise using the letters of your name.

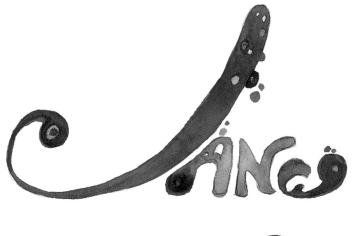

The Name Game
When I was in design school one teacher asked us to make each letter of our name lead to and suggest the next one. We could do this using any of the elements of design—color, texture, line, shape, direction, value and size. This exercise emphasizes how important passage is to eye-pleasing design.

In my name, the "J" must think about the "A" and try to change itself using one or more of the design elements to look like the "A" as it nears it. The "A" changes to look like the "N" and the "N" tries to become the "E." The "E" can reflect qualities of the "J" to keep all of the letters related. Shown is a simple example of this with black letters.

Try Using a Variety of Elements
See how the elements of design lead your eye through these examples. Notice where the shapes or lines go from big to small, where the direction goes from curved to diagonal to vertical to diagonal and back to curved again, where the colors change from warm to cool and back to warm. The values change from dark to light, and some areas have visible texture while others are smooth. A line can go from thick to thin, solid to broken, smooth to irregular. All of this is fascinating to the eye. Getting one shape to introduce the next one is one of the main skills that will help you succeed in creating marvelous passage.

Passage Devices

An occasional "name game" doodle will help you to better understand passage. Such exercises will stretch your creativity so that in your painting when you need to make one shape "talk to" another you will be able to. This is very useful when you want the tree, sand and water to speak the same language in a painting and be related to each other for unity in the composition.

Here are some of the many ways you can create passage in a painting:

- **Use strong, visually linked light shapes against strong, visually linked dark shapes.** This method creates passages that are the most easily seen. There should be a dominance of either dark or light shapes, and the overall shapes of light and dark should be irregular.

- **Create variety within and among shapes.** The most-pleasing shapes have a variety of edges, from lost (soft) to found (hard), smooth to irregular. Avoid shapes that look geometric or predictable.

- **Create soft edges.** Fluid edges encourage the eye to keep moving. A painting with only hard edges—which tend to grab and hold the eye—traps the viewer within one part of the painting at a time and encourages the eye to jump rather than flow from section to section.

- **Overlap shapes.** This invites the eye to move through them. Study good examples of overlapping shapes, such as oriental mountain scrolls or Cézanne's later paintings.

- **Practice repetition.** Repetition is an eye charmer, *if* each repeat of a shape or line is always a little different than any other. The eye loves to follow creative changes in repeats, but is quickly bored with exact repeats.

- **Present changes.** Almost any change— even gradual—of texture, line, shape, direction, size or value is pleasing and directs the eye to move along it.

- **Include variations of color.** Colors that change from warm to cool, dark to light, intense to quiet and complement to complement in a shape, line or section of a painting invite the eye to move along them.

- **Change colors from the foreground to the background.** Be sure that no color in the foreground repeats exactly in the background. Even the middle ground should have its own collection of colors not used anywhere else. This is called "integrity of plane," and it is the most important way to convince the eye of depth in representational painting.

- **Try line extension.** Think of a painting as a tapestry, woven of vertical and horizontal threads created by the edges of shapes. These threads, or line extensions, help hold a composition together and also provide some added interest in areas that otherwise might be too bland or predictable. Line extensions can be subtle or very noticeable. Even subtle line extension can lend a touch of abstraction to a painting, but any subject, whether representational or abstract, lends itself to line extension.

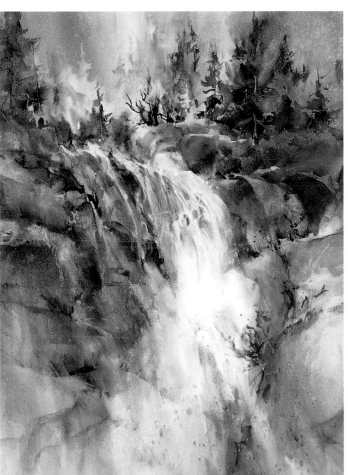

Natural Passage
Passage is easily found in waterfalls or in white water rushing down creeks or over ocean rocks. Just go with the flow and create strong, various-sized, light water shapes to carry the eye over the dark, wet rock shapes.

Sierra Cascade ~ Transparent watercolor ~ 29" x 20" (74cm x 51cm) ~ Private collection

Let Each Piece Speak to the Next

The lines, textures and colors in these rock, tree and water shapes all relate to each other yet never repeat exactly. They echo each other but still manage to be completely unique.

Splash Down ~ Transparent watercolor ~ 22" x 17" (56cm x 43cm) ~ Collection of artist

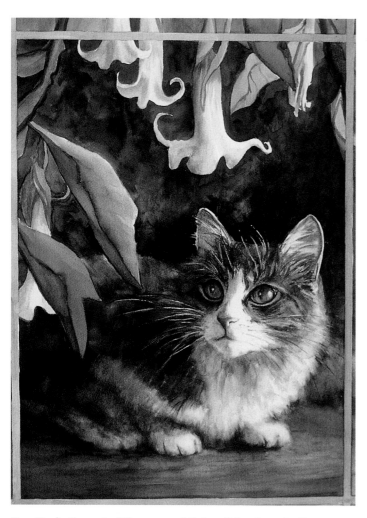

Creatively Repeated Shapes and Colors Stimulate the Eye

The scalloped paws of the cat are repeated in the scalloped edges of the flowers. Notice that each flower is similar yet not exactly alike. Also, the triangular ears of the cat are somewhat repeated in the various leaf patterns. The colors of the cat's dark fur are repeated a little differently in the background. The cat's green eyes repeat the leaf color, yet not exactly. All of this creative repetition keeps the viewer interested.

Garden Cat ~ Transparent watercolor ~ 29" x 21" (74cm x 53cm) ~ Private collection

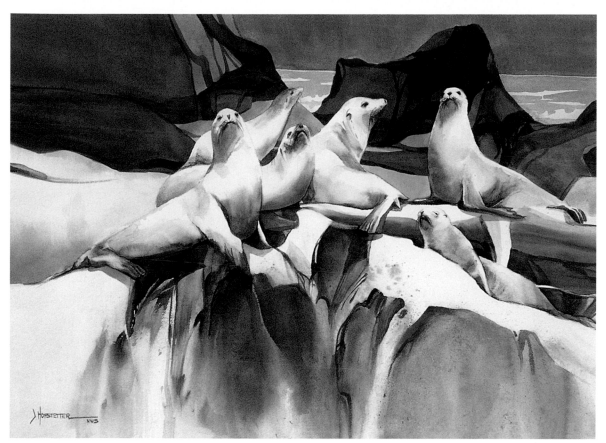

Combining Many Passage Devices

The shapes of the rocks and the seals almost echo each other as they interweave. They each have lost and found as well as thick and thin edges, plus they have gradation of value and color. The seals overlap the rocks, which in turn overlap the water. The lines and the texture in the rocks resemble the flippers on the seals, yet each rock and flipper is unique. The colors in the rocks bounce up into the seals' fur.

When you squint, your eyes can move comfortably through the darks as well as the lights in the painting without getting stuck somewhere. The horizon line stabilizes and holds together the dominant, diagonally curved lines and shapes. Lastly, look at the use of line extension: Some edges move from the top of the left rock, slant down the painting, then go across a seal's back to the ground and out at the middle of the right side. Other horizontal edges seem to weave from one side to the other, with the seals breaking the movement in places. All these devices work together to provide a great amount of passage.

Shore Shapes ~ Transparent watercolor ~ 21" x 28" (53cm x 71cm) ~ Collection of Jennifer Annette Hase ~ Awarded at Watercolor West Annual Exhibition

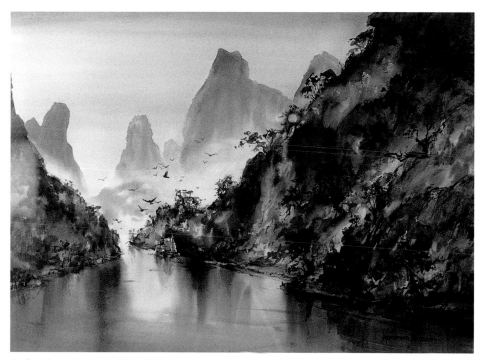

Reflections Suggest Repetition

Each mountain in this painting is a different shape and height, yet they are related. Each reflection repeats the image casting it, but not exactly.

River in China ~ Transparent watercolor ~ 21" x 28" (53cm x 71cm) ~ Private collection

Bad Passage vs. Good Passage

It's vital to plan good eye flow or passage *before* you begin painting. As you view your subject, always ask, "Where is there a boring or exact repeat of any color, size, value, direction, etc.?" I can still hear one of my art teachers, Millard Sheets, saying, "Don't go an inch without changing something!"

Sketches will help prevent passage problems. Make as many decisions as you can beforehand, because you'll have to make plenty of unanticipated decisions during the painting process.

Let's look at an example.

What's Wrong With This Sketch?
Because there is no change in color, line, texture or value, the subjects appear flat and uninteresting. This plan needs some changes before it can result in a successful painting.

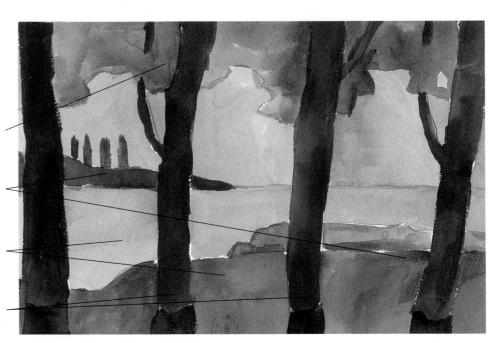

The foliage is only on the backs of the trees, and the trunks have no color or value variation to reveal their forms.

The earth and tree colors are exactly repeated in the foreground and background, ignoring integrity of plane.

The water is all in one color and value and therefore stands up like a wall, as does the foreground earth.

The trees line up like a row of tin soldiers: They and their shadows are equidistant and boring.

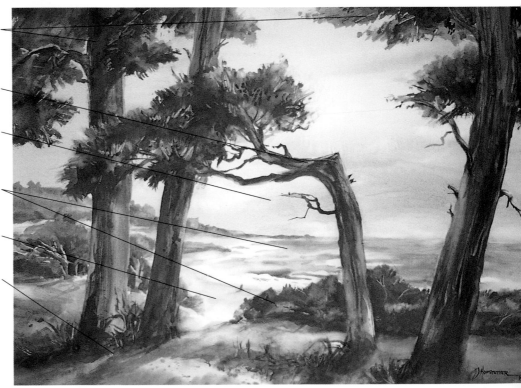

Each tree and its foliage are subtly different than the others, and the values and colors change from light to dark and warm to cool.

All the tree sizes vary, and one tree emerges as the most interesting.

Grayer colors and lighter values are used in the background areas of sky, land and water to show depth as the eye goes back.

The water changes from back to front and side to side, as does the foreground area.

The lean of the trees invites the eye to keep moving, as does the path leading down to the water.

The shadows describe the textures that they fall over in the foreground, and they indicate where the low afternoon sun is.

A Painting With Passage
Passage devices are doing their jobs in this finished painting.

Pacific Pines ~ *Transparent watercolor* ~ *21" x 28" (53cm x 71cm)* ~ *Private collection*

CREATING PASSAGE *in a* GARDEN LANDSCAPE

MATERIALS

SURFACE
- 300-lb. (640gsm) rough watercolor paper

WATERCOLORS
- **Transparent colors:** Blue Green, Carbazole Violet, Cobalt Blue Tint, Green Gold, Indanthrone Blue, Indian Yellow, Orange Lake, Permanent Magenta, Permanent Rose, Quinacridone Gold, Quinacridone Sienna, Rose Dore, Sap Green
- **Transparent earth colors:** Permanent Brown, Quinacridone Gold, Quinacridone Sienna

BRUSHES
- **Flats:** 1½-inch (38mm) and ½-inch (12mm)
- **Rounds:** nos. 2, 8 and 12
- **Slant-edge synthetic brushes:** ½-inch (12mm) and ¼-inch (6mm)
- Old ¼-inch (6mm) and ½-inch (12mm) flats plus an old no. 2 round (for applying masking fluid)
- Old bristle brush (for lifting masking fluid)

OTHER
- Silver pencil and white plastic eraser
- Masking fluid
- Small bar of soap
- Soft rag
- Trigger spray bottle

Planning the Painting

It's often beneficial to use several photos and/or sketches when composing a painting. Here are some photos of a blossoming tree and a pond in a friend's garden. One of my small sketches serves for the white herons that were visiting this garden one spring morning.

Show passage in the painting by changing some of the tree branches to resemble the birds' necks, and use the reflections in the pond to repeat the bird shapes in a broken way. Use the rock and grass shapes in the lower part of the painting to also subtly suggest the birds' forms. Use a small thumbnail sketch as a guide for light and dark value shapes.

A lush garden provides so much stimulation to the eye that it can be difficult to choose one distinct path to follow. The viewer's natural tendency will be to jump from element to element, from one beautiful flower to the next.

Take some time before composing a sketch to find some things that each of the elements in the scene have in common. If they don't seem related, find a similar color, value, shape, direction or texture that you can add to each to tie the parts together. In the following demonstration we'll create a garden scene that pleases rather than overwhelms.

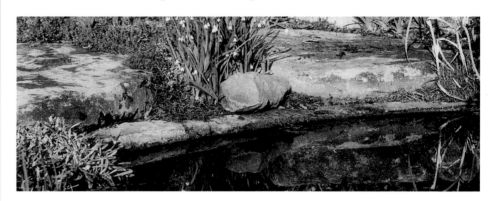

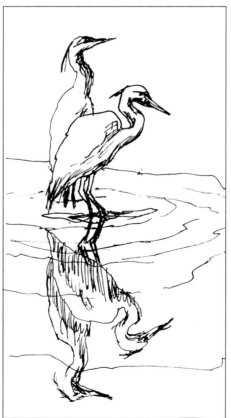

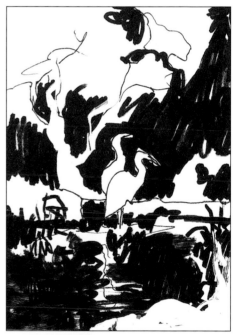

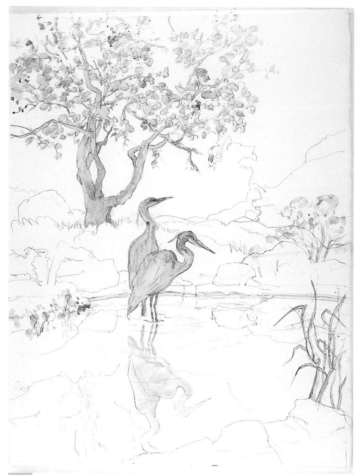

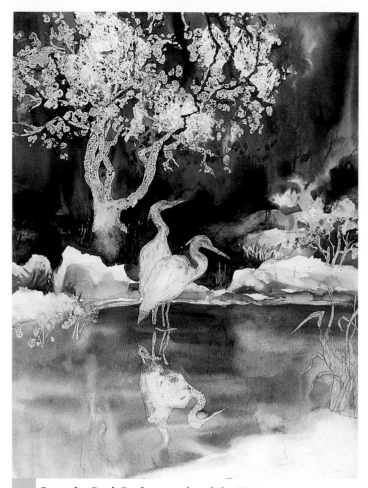

1 Make a Drawing and Apply Masking

After doing your drawing, apply masking fluid with an old brush you have dipped in water, coated with soap and then wiped off with a dry towel. (This allows you to wash the brush clean later.) Mask the tree, the shoreline, a few weeds, the white herons and their reflections in the water, and any other area that will not be easy to paint around if you want to save the white.

2 Start the Dark Background and the Water

After the masking fluid is completely dry, paint various darks wet into wet using large flats or rounds. Vary the colors of the darks for visual interest. Be sure that the paint is thick when you add it on top of a wet area, or else the values will be too light once the paint dries. Make sure that the water reflects the colors above and around it.

Use pinks and corals mixed into the background colors behind the blossoms to tie this area to the blossoms that you will paint after the masking is removed. Also use blossom colors in the garden area for repeating color among the background greens and blue-greens. Test and use several pinks; mix bluish reds and pinks using Permanent Magenta, mix true reds and pinks using Rose Dore, and make coral reds and pinks by adding some Orange Lake to your mixtures.

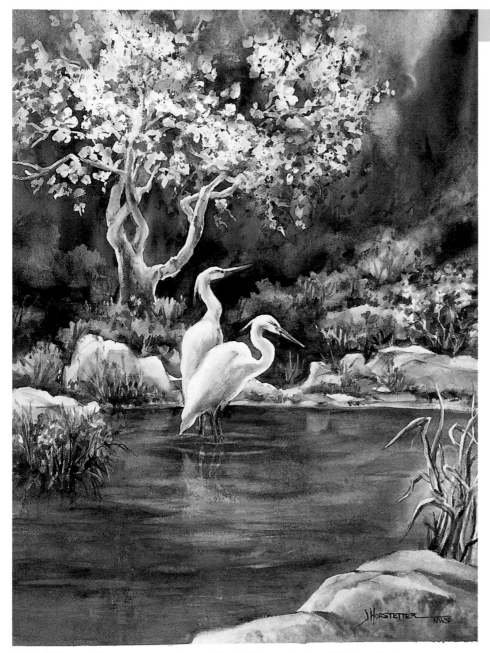

3 Remove the Masking Fluid and Finish the Piece

After the paint is dry, remove the dried masking fluid by rubbing it with a soft rag. Use a damp, stiff bristle brush to soften edges where the masking had been. Do stencil lifting to correct edges and add detail.

Using a no. 8 round, add more modeling with color and value. For the graded shadows on the birds, use reflected pinks and greens, not gray. Paint the new green leaves and apply the same colors you tested for the blossoms in step two, but leave a lot of white paper from the masked areas showing. Throw on more of the blossom colors using a large round brush, and before they are dry, spatter them a little with a water-filled spray bottle to cause the paint to spread out a bit and give the blossoms a soft look.

Continue painting, always being sure to visually connect the light shapes as well as the darks for good passage. (They don't have to touch; just make them close enough to each other so that the eye can move through them comfortably.) Check that your value shapes are all different sizes. The darks are the strongest near the focal area—the two birds—for the most drama and contrast.

Garden Visitors ~ *Transparent watercolor* ~ *29" x 21" (74cm x 53cm)* ~ *Collection of artist*

USING LINE EXTENSION *for a* NEW TAKE *on an* OLD CASTLE

MATERIALS

SURFACE
- 300-lb. (640gsm) rough watercolor paper

WATERCOLORS
- **Transparent colors:** Blue Green, Carbazole Violet, Cobalt Blue Tint, Green Gold, Indanthrone Blue, Indian Yellow, Orange Lake, Permanent Magenta, Permanent Rose, Quinacridone Gold, Rose Dore, Sap Green, Transparent Yellow
- **Transparent earth colors:** Permanent Brown, Quinacridone Burnt Orange, Quinacridone Coral, Quinacridone Sienna, Transparent Oxide Brown
- **Opaque/sedimentary colors:** Cadmium Orange, Cadmium Yellow Light, Cobalt Blue, Cobalt Teal Blue, Cobalt Violet, Manganese Blue, Raw Sienna, Scarlet Lake

BRUSHES
- **Flats:** 1½-inch (38mm), ½-inch (12mm) and ¼-inch (6mm)
- **Rounds:** nos. 1 and 6

OTHER
- Silver pencil and white plastic eraser
- Spray bottles (three varieties)
- Graphic white
- Small plastic cup
- Elephant-ear sponges and plastic stencil (optional)

Often an artist's style, if it is unusual enough, will contribute to a sense of harmony and keep the eye moving in a painting. Many artists in the earlier part of the twentieth century built their styles on what can be called line extension. Sometimes this resembles Cubism. If you want to pursue the idea of line extension in your work, you might enjoy studying paintings by Lyonel Feininger, Charles Burchfield or John Marin.

Let's have some fun working with line extension to give an abstract look to the ruins of an old pirate's castle in Les Baux, France.

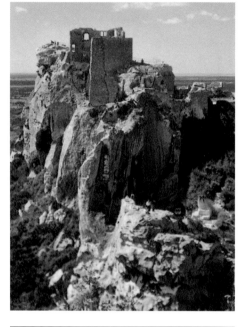

Reference Photo
For the painting, we'll change the colors from the midday cools shown in this photo to those of a warm sunset for more interesting color. Incidentally, these castle ruins are located near Arles, where van Gogh painted in southern France.

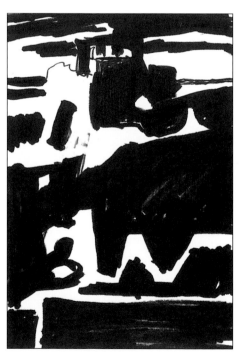

Value Pattern With Problems
The busy, dark sky makes it difficult to read the castle ruins. There is no big light shape. Boring geometric shapes will keep the viewer from staying in this composition for long.

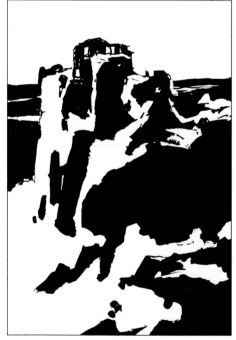

Value Pattern With Interesting Passage
This value plan is a good one because it has a variety of different-sized irregular shapes and the darks and lights connect for overall shapes that create a path for the eye. The interesting castle and land formation read well against a simple sky. The shapes have a similar feel, but each one is different.

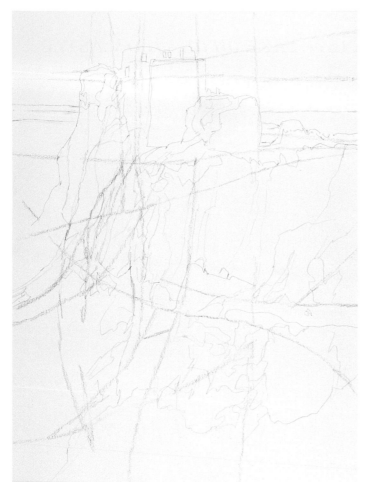

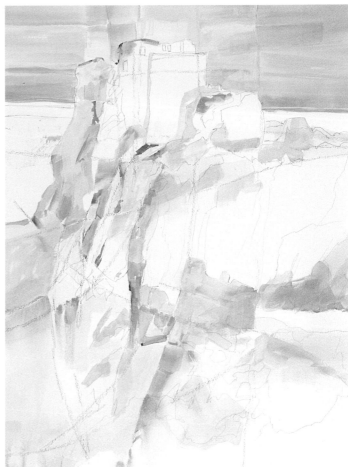

1 **Make a Drawing With Line Extensions**

Draw the shapes of the castle, rocks and horizon on your paper, then extend the lines from the edges of the main shapes—the rocks and the castle area—to the edges of the paper. (My line extensions are red so that you can see them better.) These line extensions can curve or bend to some degree as they line up with various other shapes, and they can be lost and found. The main thing is to be sure that all the new shapes are different sizes and hopefully not perfectly geometric.

2 **Start With Light Colors**

Applying paint with your flat brushes, play with all the light colors on your palette. See how many varieties of pale warm and cool color you can create, mixing some with graphic white to expand the palette range. Each time you come to a line, let the color or value change somewhat so that the shape the line extension has created will show up. If you wish, lift off some paint with a damp sponge against a plastic stencil edge to reestablish any lines that get lost.

MIX YOUR OWN GOUACHE COLORS

Mix graphic white with your watercolors (transparent or opaque) to make your own light gouache colors. Stir the graphic white in its jar until it is fluid. (I like to use the wooden end of a small brush to do this.) Then pour one-half inch (12mm) into a small jar lid or plastic cup that is clipped or taped in place on your palette. (Never dip your brush into the original jar to mix colors; that will contaminate the white.) Then mix the white and watercolor on your palette as needed.

I have found that Pelikan graphic white works best for this. The nicest quality of this homemade gouache is that it can be lifted off the paper if necessary, unlike acrylic gesso or white ink. If you're unhappy with where you've applied it, you can remove it easily.

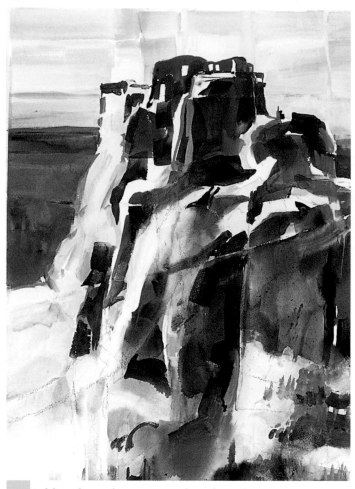

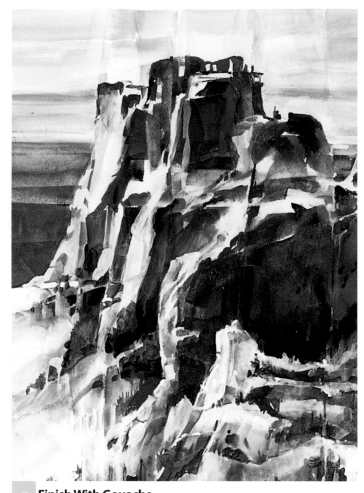

3 Add Darker Values to Complete the Value Pattern

Use your transparent watercolors to build the middle-value and dark shapes. Again, seek opportunities for exciting color changes to keep the eye entertained. Use water-filled spray bottles to make the colors run down the paper, creating new colors. As you come to the line extensions, show color or subtle value changes to help the newly created shapes stand out more clearly. Lifting off with a stencil and a sponge can be done again with the dark colors to re-establish any lost edges or lines. Use your flats to express the straightness of the line extensions.

4 Finish With Gouache

Mix graphic white with the opaque or sedimentary side of your palette to make gouache, then finish by adding it over your transparent colors in places. Apply light mixed colors of gouache wherever you think it will enhance the painting. White added to the colors can only lighten them, so you may need to go back and add some purely transparent darks to the painting before you finish. The transparent darks against the more opaque lights increase the visual excitement of the painting.

Use a spray bottle to help you soften edges in places and for spray texture on the rocks. Use small rounds for detail if necessary.

The Ruins of Les Baux ~ *Watercolor and graphic white* ~ *28" x 20" (71cm x 51cm)* ~ *Collection of the artist*

SUMMING UP *Passage*

To design a painting with good passage, keep these ideas in mind:

- Connected shapes of light against dark (or vice versa) create the easiest seen passage.

- The eye travels easily through overlapped shapes.

- For great depth in a painting, practice integrity of plane.

- Soft edges invite the eye to move through them; hard ones stop the eye.

- Colors near each other that vary in temperature, value or intensity or are complements prompt the eye to move along them.

- Gradations and variations of texture, line, shape, direction, size or value create passage.

- Edges that vary from lost and found and smooth to irregular enchant the eye and keep it moving through the painting. Irregular, imperfect shapes are more visually interesting than perfectly geometric ones.

- Repetition that is hinted, not exact, charms as it moves the eye.

- Line extension can move the eye in an interesting abstracted way.

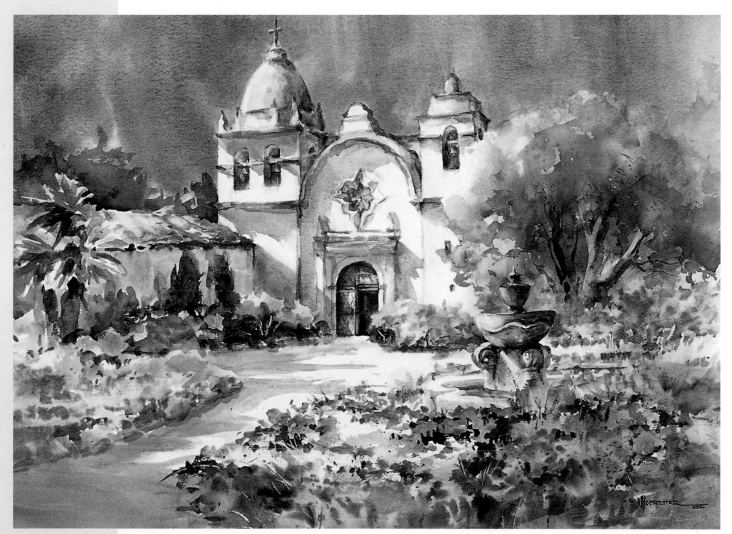

Create Colorful Shadows
Let the shadows reflect the colors around them to cause eye movement.

Mission Garden ~ *Transparent watercolor* ~ *21" x 29" (53cm x 74cm)* ~ *Courtesy of Christopher Queen Galleries*

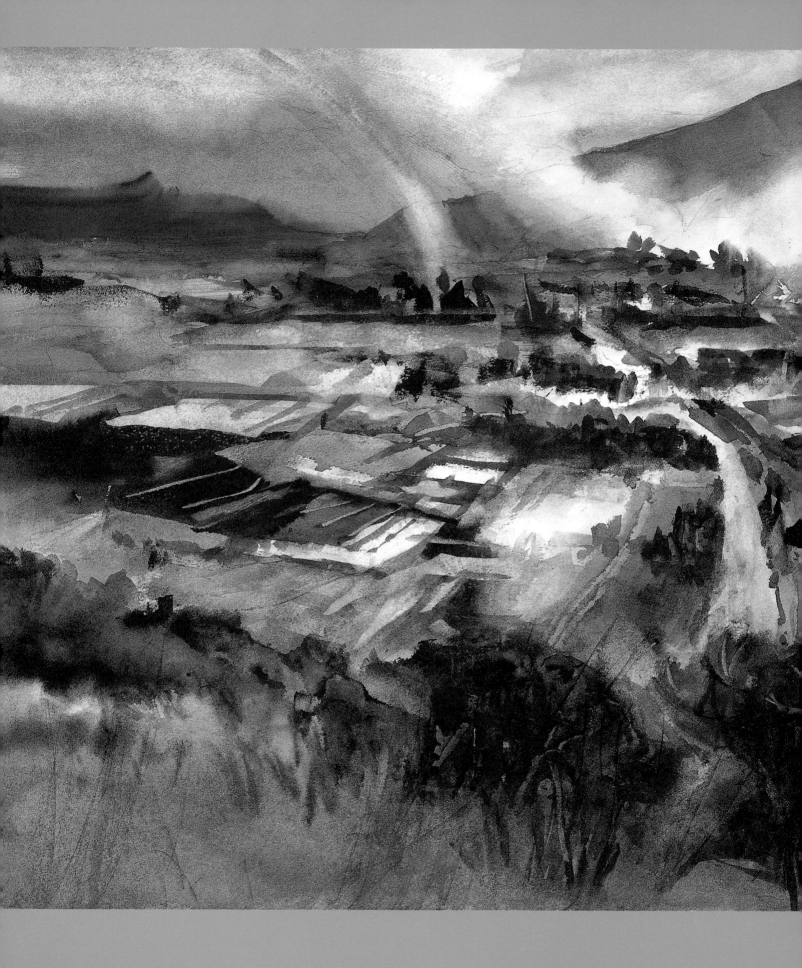

Focal Area

> *Make the focal area*
> *One-fourth of the sheet,*
> *Darkest dark, lightest light,*
> *Not same shapes that repeat.*

You have read about pattern, the bones of a painting, and passage, the flow of similar ideas in a painting. In chapter two this was discussed as the comfortable journey for the eye to take as it circulates around the painting. Now it's time for focal area, the heart of a painting. This area, the main idea of the work, is usually the most complex and visually beautiful. The eye will see this small area of the painting as a home to return to again and again. Any painting, whether abstract or realistic, must always have a heart—a strong focal area—to keep the eye interested. Without a good focal area, the painting becomes wallpaper to the eye. If this area gives enough strength and meaning to the painting, the painting will probably be remembered forever by the viewer.

The Breaking Sun Can Be a Great Focal Area
I painted this scene from a lucky moment I captured on film. The rainbow shooting through the clouds attracts the eye immediately and leads it into the painting.

Hanalei Valley ~ Transparent watercolor ~ 21" x 28" (53cm x 71cm) ~ Collection of Karin Latham

Make One-Fourth of Your Painting the Focal Area

The focal *area*, not the focal *point*, is roughly 25 percent of the painting. This area is like a window placed in one of four places within the painting. It can be called the window of opportunity, as it really makes a piece shine.

The focal area should always overlap the center of a painting, so it is important to locate the center of the painting after you have drawn the correct paper size in your preliminary sketch. If the focal area is in the upper left or upper right, it overlaps the lower half of the painting, and a lower focal area overlaps the upper half. The placement of this important area is one of the first things to think about when you begin your drawing.

There are numerous ways to draw attention to your focal area. Try to include one or more of the following:

- the lightest light next to the darkest dark
- the most-irregular shapes and edges
- some unpainted white paper
- the hardest edges
- the most-intense color (including interacting complements or unexpected color)
- the most-detailed texture
- diagonal lines and shapes
- a human figure
- any living thing, such as an animal, with implied movement
- the most-unusual or most-irregular object in your painting
- a single, unrepeated object

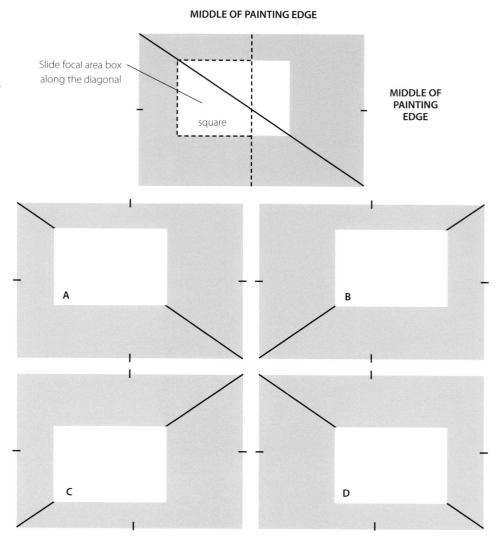

MIDDLE OF PAINTING EDGE

MIDDLE OF PAINTING EDGE

Slide focal area box along the diagonal

square

A

B

C

D

Four Focal Area Options

To place the focal area on the paper, first mark with pencil the middle of each of the four sides of the paper. Measure from one corner of the paper to each of the adjacent midpoint marks, then cut a rectangle of those dimensions. Depending upon which area you want your focal area to be in, draw on the paper a light diagonal line that the corners of the rectangle will fall on. Then slide the focal area box along the diagonal until the "square" of this focal area matches the top and bottom midpoint marks.

In the beginning you might draw a light line around the focal area in your drawing for easy reference. After some practice, you can simply visualize it.

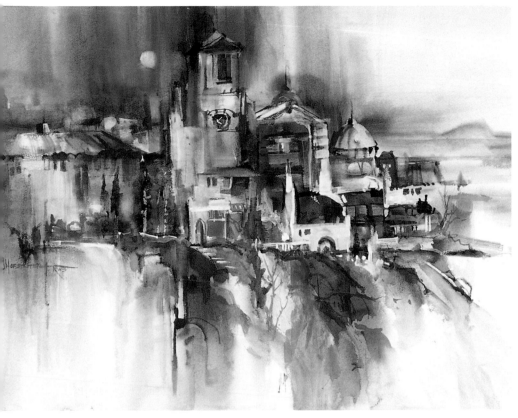

Lead the Eye From the Edges of the Paper to the Focal Area

Notice how everything leads to the focal area in the upper right. Here is where the buildings become the most interesting, with the strongest value contrast, the hardest edges and the most detail. A few curved shapes among the dominant horizontal and vertical ones add interest to the scene.

Hilltown Sunset ~ Transparent watercolor and graphic white ~ 21" x 29" (53cm x 74cm) ~ Collection of the artist

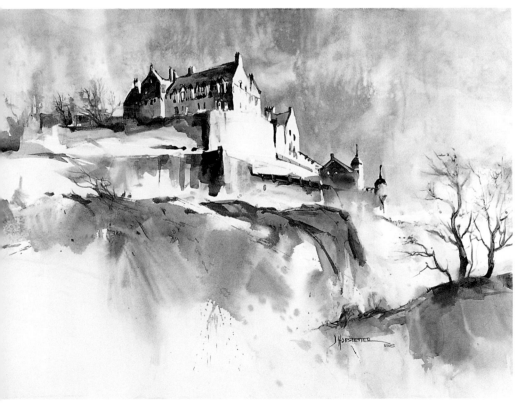

Save the Hardest Edges and Lightest Paper for Your Focal Area

The crispest shapes, along with strong contrast of light against dark, pull the eye to them. In this painting, the eye moves along the vertical thrusts of the castle. The focal area is in the upper left.

Scottish Winter ~ Transparent watercolor ~ 21" x 28" (53cm x 71cm) ~ Private collection

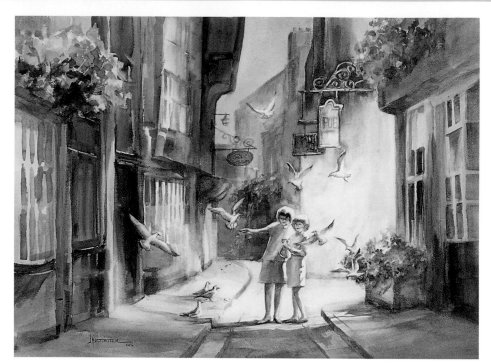

Motion and Human Figures Always Capture the Eye

Notice how the buildings and foreground move into shadow, letting the light shine on the figures and bird action in the lower right. Think of your painting as a stage setting with lighting arranged to enhance the players.

A Bird's Breakfast ~ Transparent watercolor ~ 21" x 29" (53cm x 74cm) ~ Collection of the artist

Using Personal Symbols to Define the Focal Area in an Abstract Painting

After visiting Egypt, I wanted to hint at "secret chambers" in an abstract way. Using some of the ancient writing and my own stencils, the painting began to grow. With such an active focal area in the upper right, the need for simple areas elsewhere was evident. The focal area was also enhanced with colors equidistant on the color wheel—dominant red-orange supported by grayed blue-violet and yellow-green for accents.

The Guardian ~ Watercolor, mixed media and collage ~ 21" x 29" (53cm x 74cm) ~ Collection of the artist

Make the Rest of Your Painting Secondary

To make a strong focal area, quiet the surrounding areas, including the background, somewhat. These tips can help you do this:

- Make the background slightly out of focus.

- Simplify the background material.

- Make the colors less intense and less noticeable in general; use quiet values and subtle transitions.

- Leave only a little white paper, and use little contrast.

- Only hint at texture.

- Use the background shapes to point to but not overpower the focal area.

RECOGNIZE THE EFFECT OF SOFT EDGES

Buy an extra clear lens for your camera and rub a little petroleum jelly around the outside edge. Attach the extra lens, shoot a roll of film, and see how the focal areas stand out with their crisp edges against the soft background. This is a great technique for portraits or close-up subjects.

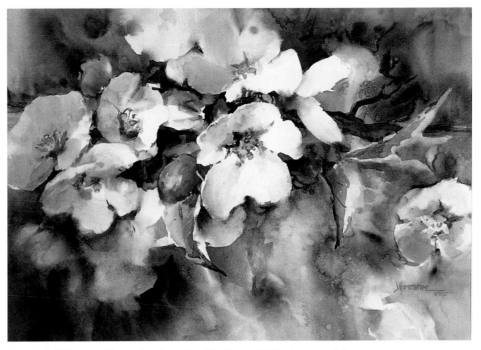

Use Soft Edges to Move the Eye Quickly Through Background Areas
The soft, out-of-focus edges around the outside of the blossoms invite the eye to move toward the harder-edged focal area in the upper left.

Apple Blossoms ~ Transparent watercolor ~ 21" x 28" (53cm x 71cm) ~ Private collection

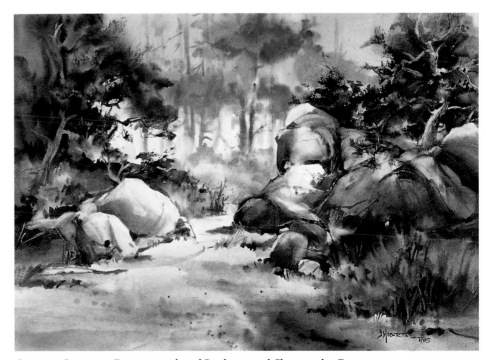

Contrast Between Foreground and Background Charms the Eye
I love foggy mornings near the ocean. In this painting, the focal area of crisp detail in the upper left is contrasted by a hazy, mysterious background.

Morning Walk ~ Transparent watercolor ~ 21" x 28" (53cm x 71cm) ~ Collection of artist

Simplify the Background for a Complicated Focal Area

The human form always attracts the eye, as we humans love to see ourselves represented in art. First we usually seek the eyes, or the face in general if the eyes are difficult to see. With a simple wall as a background behind an elaborately costumed figure, we are better able to read this painting. Irregularly sized background shapes work well against a figure and make it look more interesting.

Beefeater ~ Transparent watercolor ~ 21" x 28" (53cm x 71cm) ~ Private collection

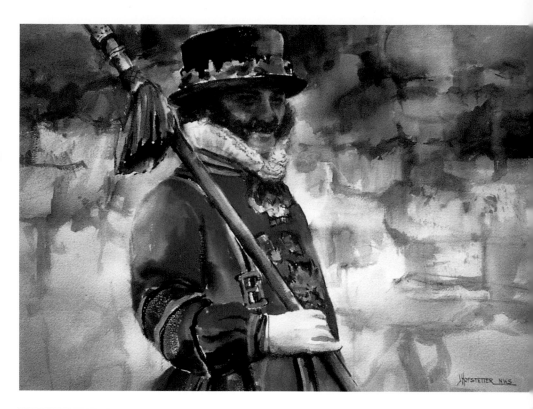

Make Focal Area Whites Look Brighter by Toning Down All Other Areas

Notice how the white areas of foam look brilliant compared to all the other lights in the painting. Mixing graphic white with your watercolors makes wonderful gouache (or light opaque) colors for the rocks and water. This effect would be hard to duplicate in a transparent-color-only seascape, as it is much more difficult to plan ahead of time where you will save the paper for whites or lights. Unpainted paper makes the best white, so always try to leave some untouched paper in the focal area. For *Approaching Storm*, I added a darker wash on much of the background to tone it down and let the water sparkle.

Approaching Storm ~ Watercolor and graphic white ~ 21" x 28" (53cm x 71cm) ~ Private collection

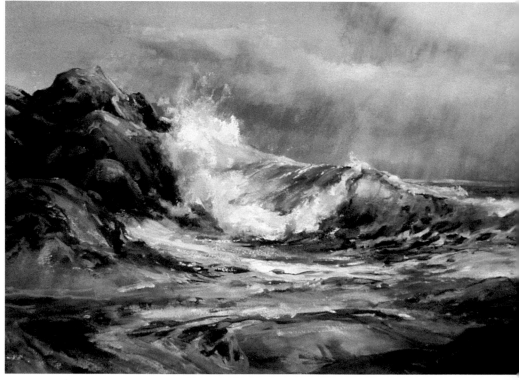

The "Eye of the Rectangle": Developing a Focal Point

Within every focal area is a certain point, a focal point, that grabs the eye. I call this resting point the "eye of the rectangle."

If you use this point for the placement of a small figure, a bit of bright color or another eye-catching element, it will enrich your focal area. This is not necessary, however, if a strong and quite interesting focal area has already been developed.

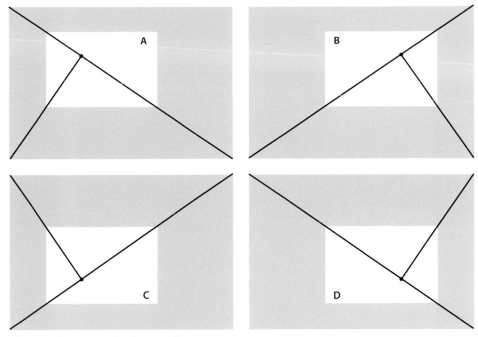

Finding the Eye of the Rectangle

To find the "eye," draw a diagonal line from an upper corner of the painting through both corners of the focal area and out through the opposite lower corner of the painting. Then draw a perpendicular line from the outside corner. Where the two lines intersect is the eye of the rectangle.

Figures Help Establish a Focal Area

In a busy village scene, figures are often the focus of the focal area. The viewer will always seek the human element to focus on first—and return to it again and again—so be careful where you place your figures.

Village in Cornwall ~ Transparent watercolor ~ 21" x 29" (53cm x 74cm) ~ Collection of the artist

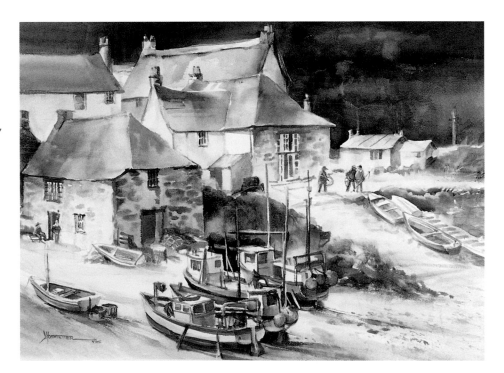

An Abstract Beginning

This painting began as a demonstration for a class. The class picked an abstract shape plan and color scheme. When the wet-into-wet shapes were dry, the painting seemed to suggest rocks and surf. Detail was added to this theme as the demonstration progressed.

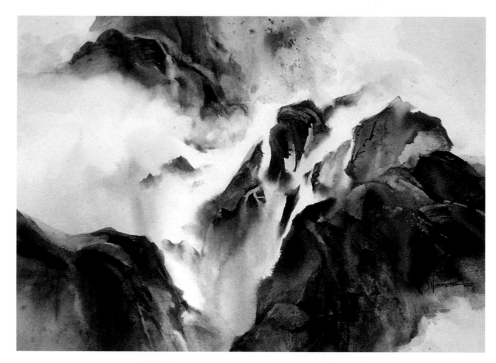

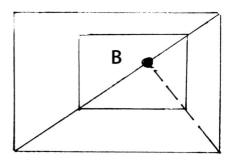

Eye of the Rectangle

The upper right is the focal area for this scene. By locating the eye and then placing a bird there, we added interest and emphasis to the focal area.

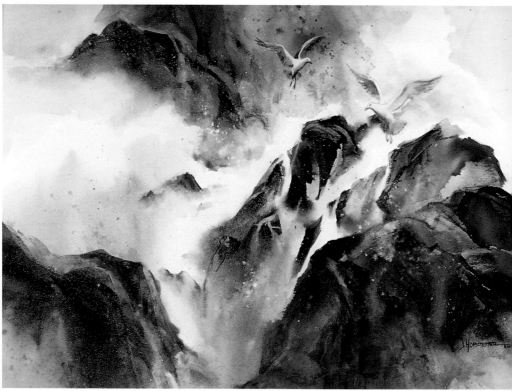

A Representational Finish

The abstract lights and darks reminded me of gulls' wings, and so I added two birds, placing one in the eye of the focal area. This turned an abstract painting into a representational one. The once abstract shapes resemble the surf breaking on a rocky shore, and the birds add scale. Anything showing movement will enhance a focal area.

Surf Play II ~ Transparent watercolor ~ 21" x 29" (53cm x 74cm) ~ Private collection

What Would You Do to Make a Better Focal Area?

When you work from reference photos, you will find that some scenes present an obvious focal point or area—perhaps it drew you to the scene in the first place—while others will not be so obvious. When you discover or create a suitable focal area, remember to eliminate all the unnecessary distractions that a camera catches and that may detract from your focal point.

Let's look for potential focal areas in the following photos and see how we can improve upon them and their surrounding areas to make the best painting. A few of the many possible options are presented at the bottom of this page.

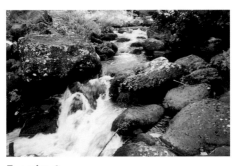

Exercise 1
This photo has a good focal area (in the upper left), but what would you do to the foreground?

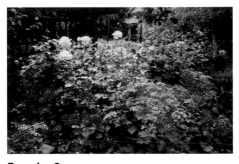

Exercise 2
Again, the upper left is nicely lit and suitable for a focal area, but how could you make it more interesting to hold the viewer's attention?

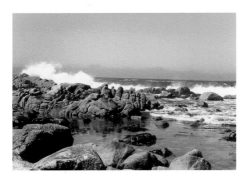

Exercise 3
What would you do to create the most excitement in the upper-right focal area?

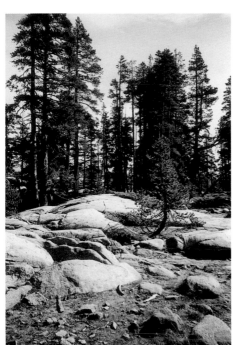

Exercise 4
Where would you place the focal area, and how would you make it the most dramatic?

POTENTIAL SOLUTIONS

- **Exercise 1:** Lighten the rocks or put the foreground white water into shadow to decrease the light and dark contrast and make the focal area in the background stand out more.

- **Exercise 2:** Place the lightest and brightest flowers in a more irregular pattern, possibly with big, medium and small shape arrangements.

- **Exercise 3:** Move the highest and most-irregular-edged foamy wave that breaks the horizon to the upper right. Put some shadow on the foreground area and rocks, and crop the sky to raise the horizon line. To see the finished painting, turn to page 53.

- **Exercise 4:** The photo is almost equally divided into trees and rocks. You might crop half of the rock area and lighten the small curved tree so it reads against the back dark trees. This makes the lower right the focal area.

BUILDING UP A FOCAL AREA *in a* FOREST SCENE

MATERIALS

SURFACE
- 300-lb. (640gsm) rough watercolor paper

WATERCOLORS
- **Transparent colors:** Carbazole Violet, Cobalt Blue Tint, Green Gold, Indanthrone Blue, Indian Yellow, Orange Lake, Permanent Magenta, Sap Green, Transparent Yellow
- **Transparent earth colors:** Permanent Brown, Quinacridone Burnt Orange, Quinacridone Coral, Quinacridone Gold, Quinacridone Sienna, Transparent Oxide Brown

BRUSHES
- **Flats:** 1½-inch (38mm), 1-inch (25mm) and ½-inch (12mm)
- **Rounds:** nos. 1, 3, 8 and 12

OTHER
- Silver pencil and white plastic eraser
- Spray bottles (three varieties)
- Flat natural sponges
- Hair dryer (optional)

L et's take the forest reference photo from exercise four on the previous page and follow through on the plan suggested for a painting.

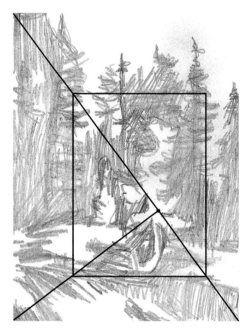

Preliminary Sketch With Changes Added

I cropped some of rock area and lightened a tree in the focal area. The white box indicates the rectangular focal area; the red line with a dot shows where the eye of the rectangle is located.

I plan to make the focal area really stand out with strong value contrast using pure white paper, the greatest amount of texture and detail, the most interesting color, strong emphasis on a tree that is slanted rather than straight like all the others and many hard edges.

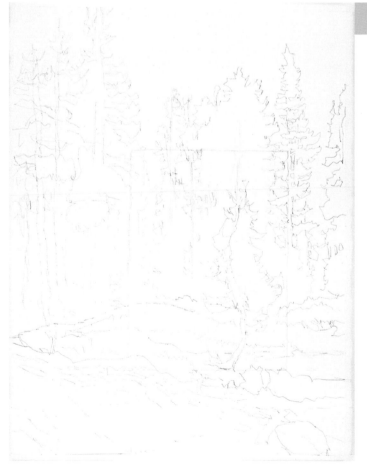

1 Make a Drawing

Draw the subject on your paper and lightly pencil in the focal area. Make a note of the location of the eye of the rectangle, as you might add a bright note of color or another eye-catching element there later for emphasis.

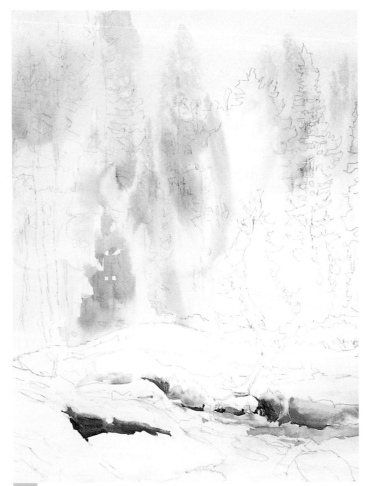

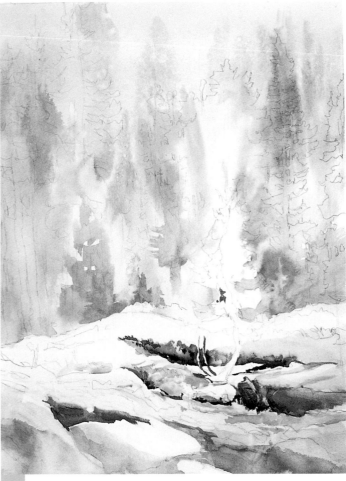

2 Paint Your Lightest Colors

Paint your palest colors first, starting with the background trees. Using large flats and rounds, paint them wet into wet. Use a spray bottle to move the colors a bit. (Always slant the board when spraying to give the colors an edge to run to.) Create some interesting color mixtures rather than using individual colors straight from the tube. The overall color scheme will be cool, but indicate some sunshine with warmer colors in the central background. Let the colors increase in intensity and value near the focal area, with warms reading against cools. Use a hair dryer if you want to dry the paint in this step quickly.

3 Develop the Middle and Darker Values

Using larger rounds, add the middle-value colors and some of the darks, all of which should relate to the lighter values. Remember to mix interesting darks. Foliage can be very boring if it is all green, and a tree trunk can be made up of many colors. Look for colors to bounce into the tree and rock shadows, which reflect nearby colors. Establish integrity of plane by varying the tree colors, even slightly, from background to middle ground and finally to foreground.

Develop the darkest darks in the focal area and next to the few brighter colors. Add any texture or detail in the focal area that will help the eye linger in this part of the painting. Check to be sure you have connected the lights together and the darks together for good passage.

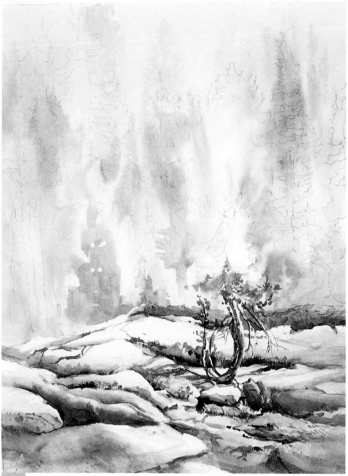

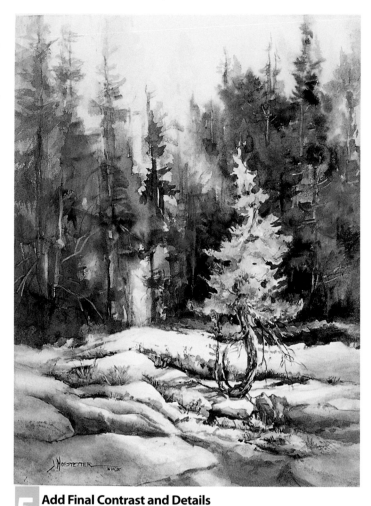

4 Develop the Small Tree in the Focal Area

Continue developing the rocky land area using your smaller brushes. Then use lots of texture detail, value contrast and warm colors for the lower part of the tree, which will be the focal point. Make it as interesting as possible and in full sunlight. This tree will seem to be dancing compared to the background trees.

5 Add Final Contrast and Details

Add lighter greens on the middle and top of the focal point tree. Carefully paint a variety of dark greens and other colors around the small tree to make it stand out in the light. Think big, medium and small dark shapes in the background. A few of the subtle background colors painted in step two should show and give some atmosphere. Allow the eye to move through the big light sky area into the small light tree and down into the light rock area under the tree for comfortable passage.

Glaze some warm yellow-oranges over the rocks at the top and some cool blue-violets over the lower rocks for more drama in the focal area.

New Growth ~ Transparent watercolor ~ 21" x 28" (53cm x 71cm) ~ Collection of the artist

Organizing your painting into one main idea with one main focal area is critical to good design. This is especially vital for working abstractly, when there is no representational subject to become emotionally involved with. Without defining a focal area, you run the risk of making wallpaper-like paintings.

Some key points to remember when establishing the focal area in your painting are:

- **The focal area should make up about 25 percent of the painting.** This creates a place for the eye to return to again and again and continue to enjoy.

- **Locate your focal area in one of four ideal places.** These places help you avoid choosing a corner or the exact center of the paper for the area of interest. The former could lead the viewer's eye right out of the painting, and the latter sets the stage for a boring experience.

- **Never lead the eye to a focal area where there is nothing much to see.** Dramatize this area the most so that the viewer's eye will perhaps find something new each time it returns "home" within the painting.

- **Save the strongest contrasts for the focal area.** These include contrasts in value, shape, line, color, size, texture and direction. Emphasis like this will bring the eye back time and again. You might add some of the brightest color, the most exciting details and a few of the hardest edges to the focal area. Some saved white in this area, in contrast to the surrounding painted areas, will also instantly attract the eye.

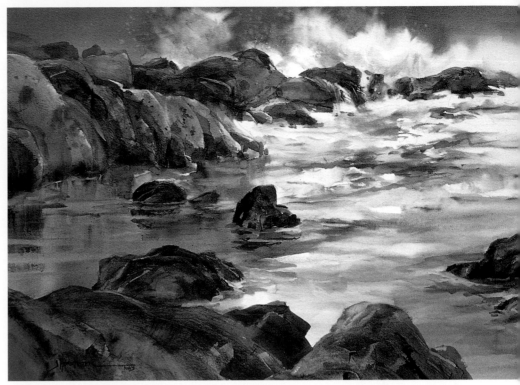

A Successful Seascape Finish
This painting is based on the reference photo of surf and rocks for exercise three on page 49 and uses the suggestions given.

Yin and Yang ~ Transparent watercolor ~ 21" x 28" (53cm x 71cm) ~ Collection of the artist

- **Give the focal area the most irregular and interesting shapes.** Many of my students have said they go to sleep at night chanting, "Darkest dark against lightest light with the most-irregular shapes makes a great focal area!" Strong value contrasts and unusual shapes immediately catch the eye, even if the viewer doesn't yet (or never does) recognize the subject.

- **Sometimes, but not always, you might choose to place a specific focal point within the focal area.** Use the "eye of the rectangle" to hold a focal eye-catcher to solidify the focal area's impact.

- **Quiet the surrounding areas.** This is as important as developing a strong focal area. Use the rest of the painting to support the focal area, not compete with it.

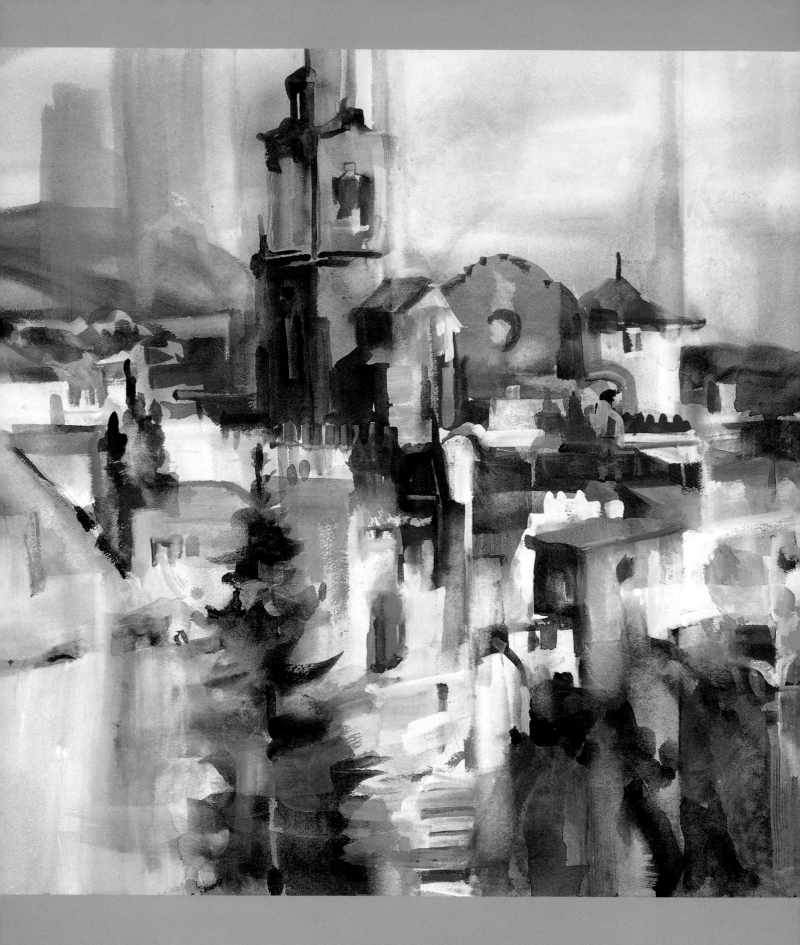

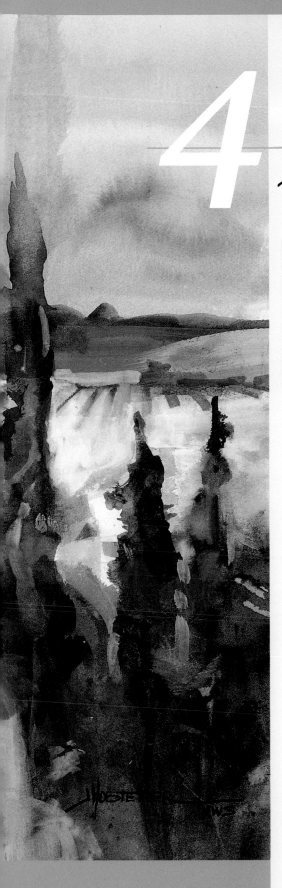

4 *Color*

Good value shapes

Constant color change,

Use the color wheel

But not the whole range.

Color is like the skin of a painting—color covers our work with feelings that can range from hot, fiery intensity to cool, peaceful quietness. Color plays many roles in paintings. Color helps identify objects through their obvious local colors. It produces movement, with warms advancing and cools receding. Even in areas where all the values look the same, color change is always apparent and interesting to the eye.

Color becomes even more appealing as we find many beautiful relationships and harmonies in the color schemes we learn to work with. Color carries with it a wealth of feelings, moods and ideas. It can enhance the dullest of subjects; it can make a drab painting beautiful. People perceive color in their own ways. When I saw an original van Gogh painting for the first time, I wept. The color chords simply sang to my heart. With your own unique color usage, you can reveal to your audience your feelings about the subject and make a powerful, unforgettable connection.

A Dawn or Sunset Can Dramatize and Change Every Color
This slightly abstracted painting of a complementary color scheme works by using many dominant reds against subdued greens.

Hill Town ~ Watercolor and graphic white ~ 21" x 29" (53cm x 74cm) ~ Collection of Karen Drucker

Know the Colors on Your Palette

My palette consists mostly of transparent colors that I often use together at the start of each painting. I know I will have only fresh, clean color when I work with my sixteen transparents. I use the eight opaque or sedimentary colors later in the painting for added color or opacity over the transparent colors. I also occasionally mix them with graphic white to create gouache colors.

As a rule, add heavy colors last in your paintings. Opaque and sedimentary paints are heavier than transparent ones and will settle into the pores of the paper when applied. If more paint is added on top of these heavier paints, the color is disturbed, and the paint lifts up unevenly and looks muddy. To get a granular effect for a sky, for instance, you can use sedimentary colors such as Cobalt Blue, Manganese Blue or Cobalt Violet. However, try to avoid painting over that area again after it has dried.

On my color chart are two wide, black India ink lines with the colors painted over them. This is one way to test watercolors for transparency. The transparents hardly show over the black, while the opaques are very evident. The sedimentary colors may appear to be transparent, but they behave differently, as mentioned above, so I group them with the opaques.

The lifted lines on the chart show that in most cases all the colors, even the most staining, are liftable to some degree. However, be sure to use a professional grade, heavyweight paper that will stand up to lifting; otherwise, the paper may tear. (I prefer Winsor & Newton 300-lb. [640gsm] cold-pressed or rough paper for this reason.) Use a damp sponge and a precut stencil on a sample of your paper to see how well the colors will lift.

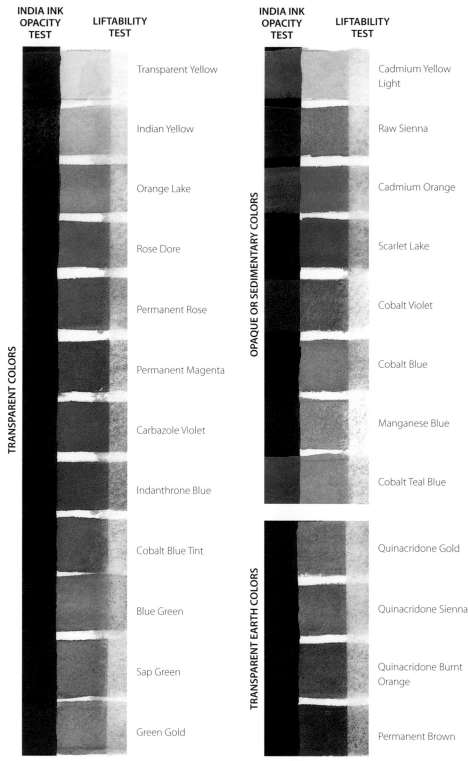

Palette Arrangement

This is the way I like to lay out the colors on my palette. I keep the transparent colors separate from the opaque and sedimentary ones, as each group behaves differently once applied to the paper. The India ink test reveals how transparent or opaque each color is; the liftability test shows how well a color can be removed, with a damp sponge, from the paper.

Understanding How to Mix Colors

The outside ring of the color wheel on this page shows the twelve colors at their strongest intensity. To allow myself to mix the full range of these powerful colors, I've found it necessary to have on my palette a warm and a cool of each of the three primary colors. To create the "true" colors shown on the wheel, I combined the following transparent tube colors:

- Indian Yellow (warm) + Transparent Yellow (cool) = true yellow

- Cobalt Blue Tint (warm) + a little Indanthrone Blue (cool) = true blue

- Rose Dore (warm) + a little Permanent Rose (cool) = true red

These are the primary colors as I see them. However, color is subjective, and everyone sees the same colors differently. I could use these three colors to mix the other nine colors, but it is easier to buy tube colors for all twelve, as well as some transparent earth colors.

Each secondary color—orange, green and violet—can be made by mixing two primaries, but they are easily made from other transparent watercolors:

- Orange Lake = true orange

- Sap Green + a little Blue Green = true green

- Permanent Magenta + a little Carbazole Violet = true violet

Each of the six tertiary colors, which lie between the primary and the secondary colors, is mixed from the primary and secondary colors on each side of it. For instance, true yellow mixed with true green equals true yellow-green, and so on.

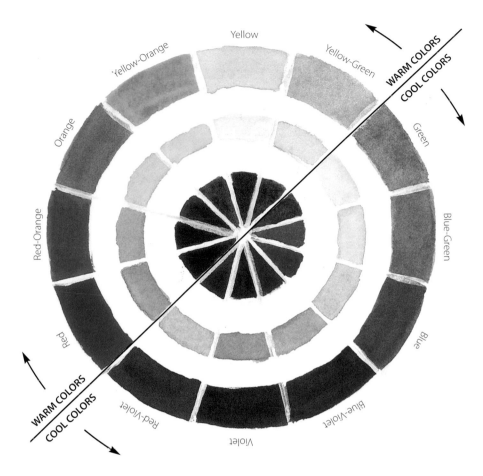

The Color Wheel
The most-intense, the darkest and the lightest versions of the colors on a standard twelve-color wheel.

The middle ring of the color wheel shows all the twelve colors at their palest strength. These tints are usually created by just adding water to the outside colors. The inner ring shows the darkest version of each color. These shades can be created by using the colors with little or no water.

Any of the colors in its palest form can be used to enhance any color scheme by giving variety to the lighter areas. The darkest shade of any of these colors can be used to enhance any color scheme by giving variety to the darker areas. I call this "color searching" the darks and lights, which you'll read about later in this chapter.

To create colorful grays, mix complements (opposites on the color wheel). You can make the gray swing toward warm or cool simply by using a little more of the desired temperature. For a fine collection of darks, use Permanent Magenta, Sap Green and Indanthrone Blue along with the darker transparent earth colors.

Get Exciting Results With Glazing

Glazing is accomplished by layering washes of transparent color. The most important thing to remember when glazing is to be sure a wash is bone dry before going over it with another wash. Using a hair dryer dulls the color slightly, so try to allow the paper to dry naturally between washes.

Any transparent color can be layered for glazing, but it's customary to begin with the warmest color in your scheme and progress to the coolest color. I generally use a one-inch (25mm) soft sable wash brush since it seems to disturb the underlying layers the least, but you can try a round or flat to see which you find easiest. (The type and size of the brush depends on the size of the area you are glazing as well.)

Here are some ways that you can use glazing to enhance your painting:

- **Glaze dull, drab places in your painting to make them glow.** Even the most subtle glaze can change the color or temperature just enough to enliven an area.

- **Use glazes to connect areas of a painting.** Glaze spotty, busy or disconnected places with the overall dominant color to help tie them in with the rest of the painting.

- **Use glazes to emphasize or de-emphasize certain areas.** Draw attention to your focal area by building intense layers of color. Quiet supporting areas with an overall glaze of subdued color.

- **Enliven shadows with transparent glazes.** Cast shadows become more luminous when the local color of the shadow is applied first, then a darker shade of that color is glazed, then the color of the object casting the shadow is glazed on top.

- **Give a sky loads of atmosphere with warm-to-cool color glazes.** The more glazes, the more atmosphere and mood. Go from darker in value at the top to lighter at the bottom. Changing the value or temperature from side to side is exciting to the eye also. Try painting distant buildings at the back of a low-horizon field and letting the glazed sky dominate the painting for a powerful effect. Repeat the sky colors in the rest of the painting for a harmonious effect.

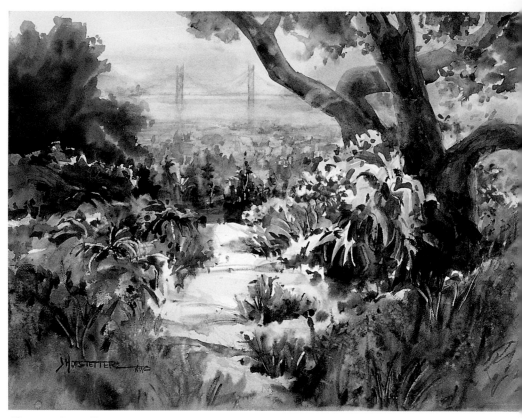

Glaze an Overall Area to Tone It Down
I love to glaze over the foreground of a painting with a wash of Cobalt Blue Tint, letting this area go into shadow to give the focal area in the middle ground more shine. Doing this for *Marjory's Garden* gives more strength to the focal area in the upper right.

Marjory's Garden ~ *Transparent watercolor* ~ *53" x 71" (135cm x 180cm)* ~ *Collection of the artist*

LIGHTFAST COLOR ENDURES OVER TIME

It is horrible to have a painting ruined because the color has faded. For this reason, make sure that you use permanent, lightfast watercolors. Fortunately, there are books on the permanency of watercolor to help guide you in your choices. However, a nonfading color in one brand might fade in another, so be careful.

Incidentally, many museums store all watercolors in basement archives and show them for only a week or two during the year due to the watercolor paint's fading. Hopefully this will change over time if more watercolorists use only lightfast, permanent paint. Label the back of your artwork "lightfast color only."

Eight Essential Color Schemes

My students have enjoyed using this small color wheel and its various color schemes, which can be cut out after the page is photocopied and laminated. As you paint, these are handy to refer to for the various options.

Every work of fine art needs warms and cools. Don't forget that warm schemes should use cool grays and cool schemes should use warm grays. This will help balance the colors in your painting

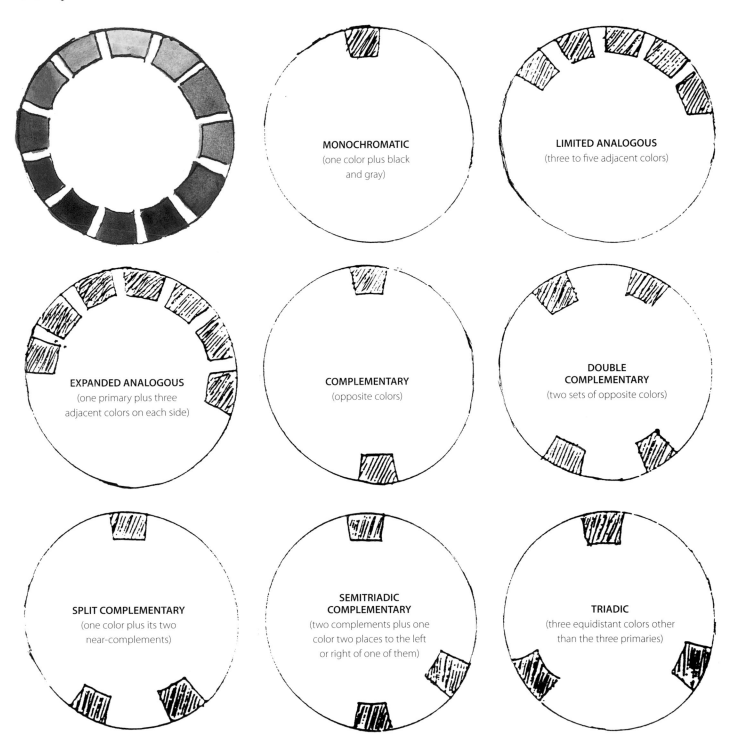

MONOCHROMATIC
(one color plus black and gray)

LIMITED ANALOGOUS
(three to five adjacent colors)

EXPANDED ANALOGOUS
(one primary plus three adjacent colors on each side)

COMPLEMENTARY
(opposite colors)

DOUBLE COMPLEMENTARY
(two sets of opposite colors)

SPLIT COMPLEMENTARY
(one color plus its two near-complements)

SEMITRIADIC COMPLEMENTARY
(two complements plus one color two places to the left or right of one of them)

TRIADIC
(three equidistant colors other than the three primaries)

Choosing a Color Scheme for Your Subject

Color should come from an artist's feelings and intuition about a subject, not simply the subject's local or photographic color. Fifty artists could all paint the same subject, and each painting would be different. Using only the colors seen on a subject can be the kiss of death to a creative painting. To arrive at a good color scheme, ask yourself some questions. What kind of a mood does the subject present to you?

Determine the special qualities of your subject, its history. The painting of the ancient castle ruins in Les Baux, France (see page 38) changed from the daytime colors of my photo to intense sunset colors because of what I knew of the castle's history and how I felt about it. It has been said that long ago, the lord of the castle gave his wife some of her lover's heart to eat for dinner. When the lord's wife learned of his cruel action, she leapt off the battlements to join her lover in death! So, of course, I had to paint the piece predominantly red; I used a quieter green for the complement in this scheme. I also felt the need for dramatic value contrast.

Not all subjects have such tragic or emotional histories, but they should evoke feelings. Translate those feelings into color choices and value patterns whenever possible.

Monochromatic Color Scheme
This somber winter scene seemed to suggest a limited, quiet palette. I used Quinacridone Sienna with cool gray for the monochromatic scheme. Light to dark versions of these colors provided the value ranges, with the greatest amount of contrast being in the upper-left focal area.

Early Thaw ~ *Transparent watercolor* ~ *21" x 29" (53cm x 74cm)* ~ *Purchase Award recipient at Watercolor West Annual Exhibition*

Complementary Color Scheme
The dominant blue-greens are enlivened with red-orange touches in the upper-right focal area. Remember that any dark or light color that is dark or light enough will work in any color scheme. Rocks are darkest when they are wet, so here I enjoyed playing with all twelve darks on the wheel.

Below the Falls ~ *Transparent watercolor* ~ *21" x 28" (53cm x 71cm)* ~ *Private collection*

Double Complements

Because of the light, delicate mood of this spring day, I chose to use less-intense, warm double complements of pink for the red-violet, and coral for the red-orange. The blue-greens and yellow-greens are dominant.

All Dressed Up For Spring ~ Transparent watercolor ~ 21" x 28" (53cm x 71cm) ~ Private collection

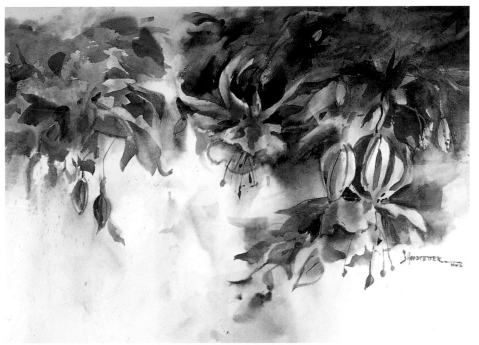

Split Complements

Split complements were a natural choice for this painting of red flowers against yellow-green and blue-green leaves. The reds can swing toward red-orange and bluish red also, which gives wonderful split complements.

Dancing Ladies ~ Transparent watercolor ~ 21" x 28" (53cm x 71cm) ~ Collection of Bill and Mickie Robinson

Triadic Colors

In this painting yellow-green is dominant, and smaller amounts of blue-violet and red-orange add interest to the focal area in the upper right. In my opinion, only one triad doesn't work: red, yellow and blue. That scheme often becomes garish because of the strong intensity of each color.

Field Flowers ~ *Transparent watercolor* ~ *21" x 29" (53cm x 74cm)* ~ *Private collection*

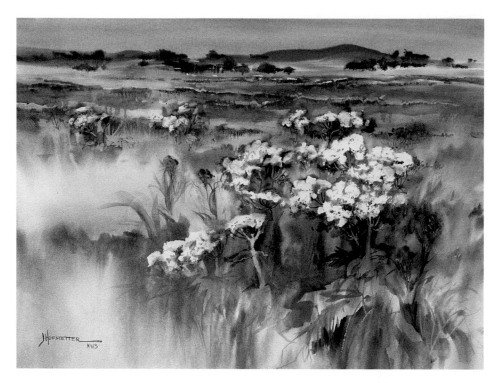

Semitriadic Complements

One of my classes chose this interesting color scheme for this painting. It was fun to use the warms first, rather lightly, and darken down to the cools. The complements blue-violet and yellow-orange are accompanied by red-orange as the extra color, which gives more interest to the yellow-orange.

Old Europe ~ *Watercolor and graphic white* ~ *29" x 21" (74cm x 53cm)* ~ *Collection of the artist*

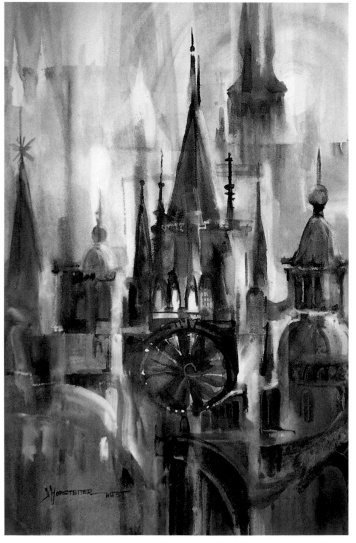

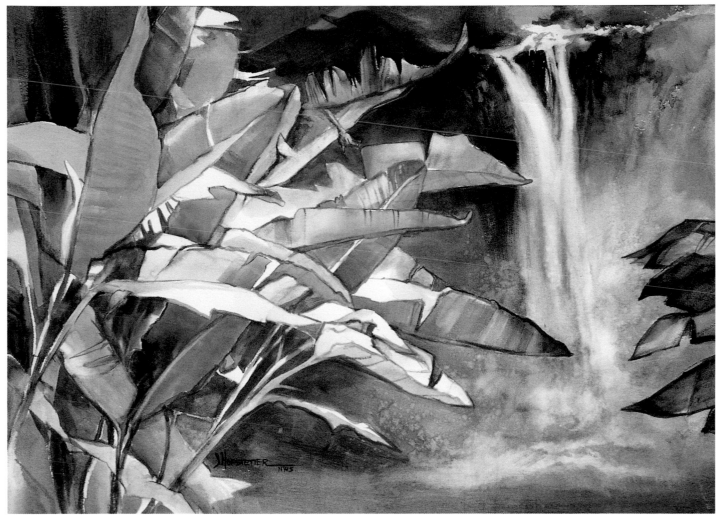

Limited Analogous Colors

A variety of lush greens were a natural choice for this outdoor scene. I chose yellow-green as the dominant color, using five colors in addition from yellow-orange through blue-green. In this scheme grays play a big part in balancing the analogous colors. The subtle blue-grays that swing from turquoise to violet allow the brighter green colors to shine.

Picnic View ~ Transparent watercolor ~ 21" x 28" (53cm x 71cm) ~ Private collection

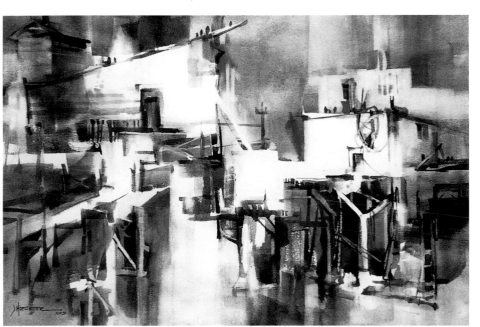

Expanded Analogous Colors

In this abstract painting, the dominant primary color is, of course, red. Blue-violet, violet, red-violet, red, red-orange, orange and yellow-orange are a powerful combination. The blue-violet provides a little cool balance.

As I did with this painting, I often allow someone else to choose the color scheme, even if it is opposite of what I think it should be. This forces me to try new approaches to a subject, stretching my creativity each time I paint.

Wharfwood #2 ~ Transparent watercolor ~ 21" x 28" (53cm x 71cm) ~ Purchase Award recipient at San Diego Watercolor Society Annual Exhibition

A Foolproof Color Scheme for Any Subject

Here is the color wheel arrangement I often use because it is so easy and gives a perfect color scheme every time I use it.

Start with the color wheel that appears on page 57, with the twelve intense colors on the outside, the light tints in the middle, and the darkest shades on the inside. Use a clear, circular, plastic cover that fits over the wheel and shows all the colors except for two outside intense colors on the right side and two on the left. There are five intense colors showing at the top and three at the bottom. All of the lightest tints and darkest shades show through the plastic cover.

To use the wheel, turn it so that the color you have selected to dominate your color scheme is at the top of the wheel and the cover says "dominant" under it. For instance, if you choose blue as the dominant color for your color scheme, it will be at the top. Blue-violet and violet will be on one side and blue-green and green will be on the other side. These five analogous colors will dominate your scheme.

Notice that both violet and green on the outside edges must be made a little less intense so they do not compete with the dominant blue. Do this by adjusting the two colors so that they look slightly lighter or

grayer. In this case, four colors at the sides of the wheel are not seen: red-violet, red, yellow-green and yellow. These colors are used only in their darkest and lightest forms, since that will work with any given color scheme.

At the bottom of the wheel are the complements—orange, red-orange and yellow-orange—to the middle colors on top. These complements should be used less intensely—except in tiny amounts—so that they don't compete with the dominant color. Only small bits of intense color work well; too many large areas of intense color compete for attention.

Foolproof Color Scheme, Using Blue as the Dominant Color
This wheel gives the artist eight colors to use. The eight colors include one dominant color, four analogous colors (two on either side of the dominant color) and three complements. The darkest and lightest versions of every color on the wheel can be used as well for any color scheme.

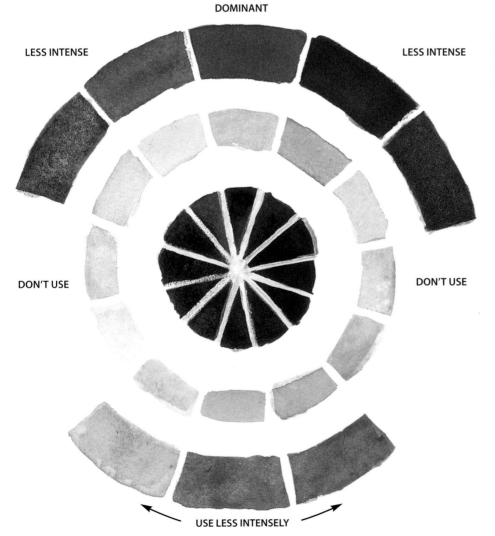

DOMINANT

LESS INTENSE

LESS INTENSE

DON'T USE

DON'T USE

USE LESS INTENSELY

Making Color Decisions as You Paint

When I demonstrate using the color wheel, I usually ask my students to look at a photograph of the subject and identify the dominant color. Then I make a quick sketch on the paper and select one of the value-shape patterns (page 16). After selecting my brushes and spraying my watercolors so that they are soft and ready to use, I am ready to paint.

Here is how the iris painting came to be, using my foolproof color scheme with blue as the dominant color.

Paint the Dark Abstract Shapes First
I laid in the darker abstract shapes wet into wet using the five analogous colors (green to violet), including intense blue, blue-violet and blue-green.

Add Some of the Complements
I added yellow-orange, orange and red-orange, but less intensely. I left the top white area of the flower unpainted; this eventually became the focal area. I avoided using intense yellow, yellow-green, red or red-violet. From time to time, I checked my colors against the color wheel, the thumbnail value plan and the reference photo.

Develop the Focal Area
As the first wet-into-wet colors dried, I defined the flower with some subtle negative painting around it. I continued to use the dominant blue color scheme and let the colors gather in intensity as they approached the focal area in the upper left.

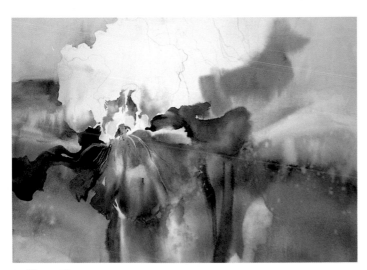

Halfway There
The painting appeared like this halfway to the finish. Notice that I used the complementary colors intensely in only tiny amounts to enhance the focal area. They are quieter elsewhere in the painting.

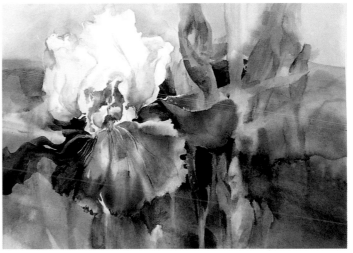

Final Details
More details were added, but nothing takes away from the brilliant blue that dominates the color scheme.

Iris Glow ~ Transparent watercolor ~ 21" x 29" (53cm x 74cm) ~ Private collection

"Color Search" Your Work as You Paint

Using color in painting doesn't have to be difficult. The main thing to keep in mind is to avoid using one color repeatedly in an area and to constantly "color search" while painting. In other words, do not go more than an inch or two (three to five centimeters) in your painting without changing the colors or values somewhat. The eye is very quick to find exact duplications of anything and loses interest quickly. Color searching will make your paintings look professional and pleasing.

When I was a design student, one of my painting teachers believed in teaching by the old methods, where mistakes were firmly punished. He walked around our classroom with a brush and color palette. As he approached our paintings, he would make a circle with his thumb and first finger and look through this small circle for mistakes. If he found a place in anyone's painting that was the same color and value within that circle, he would dip his brush in black paint and make a large "X" over the entire painting!

I learned quickly never to dip into the exact same color twice. To this day I try never to go too far into my painting without changing something. I enjoy my color passages now, as they continually shift and change. As you practice color searching, think warm to cool, light to dark, intense to less intense, and complement to complement. It may take you a while to get the hang of color searching, but your work will grow enormously.

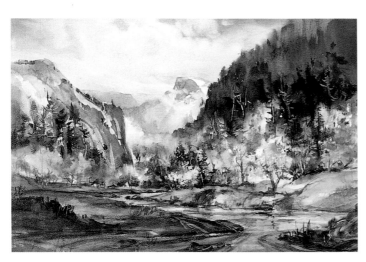

Color Searching Brings Interest to Repetitive Subject Matter

Yellow-orange is the most intense color for these aspen trees. The analogous colors red-orange, orange, yellow and yellow-green border the yellow-orange. Blue-violet, violet and blue are the complements used. Notice how the dark hill is color searched and how the fall trees are intensified in the upper-left focal area. The Cobalt Blue Tint glaze over the foreground draws attention to the focal area.

Yosemite Autumn ~ Transparent watercolor ~ 21" x 28" (53cm x 71cm) ~ Private collection

Rooftops of Many Reds

The analogous colors of dominant red-orange with red, red-violet, orange and yellow-orange show off these rooftops in Spain. The goal was to make each rooftop different than any other in the painting by color searching the reds.

Spanish Rooftops ~ Transparent watercolor ~ 21" x 28" (53cm x 71cm) ~ Private collection

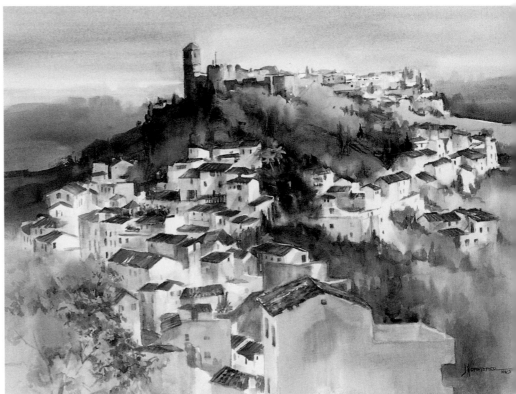

Use Color to Emphasize Different Aspects of a Subject

When I get excited about a certain subject, I find myself painting it over and over again. The exploration of various moods, times of day or other ideas can provide endless inspiration. Monet loved the light on his water lilies to such an extent that he continued to paint them for most of his life. Stretch your abilities as an artist by continuing to make a new statement each time you paint something you love and know well.

Using different color schemes, I have enjoyed painting the beautiful Carmel Mission many times and in many different ways. Here are examples of some of the various viewpoints I have enjoyed seeking out as I painted the mission.

Lively Color

A dominant "true blue" scheme is used here in the sky and flowers, and it is bounced into the shadows on the walls. Touches of the split complements (red through orange) move the eye from place to place. A strong perspective (looking up) gives the mission a sense of nobility.

Afternoon Shadows ~ *Transparent watercolor* ~ *29" x 21" (74cm x 53cm)* ~ *Private collection*

Dramatic Color

When you have painted a subject's many moods, try a night version. It usually makes a very dramatic statement. This night sky contains all the dark shades on the color wheel. The dominant reds range from orange through red-violet in the flowers, and red bounces up onto the mission bell tower walls. A weaker green complement helps the reds to vibrate.

Carmel Mission in Moonlight ~ *Transparent watercolor and graphic white* ~ *28" x 21" (71cm x 53cm)* ~ *Courtesy of Christopher Queen Galleries*

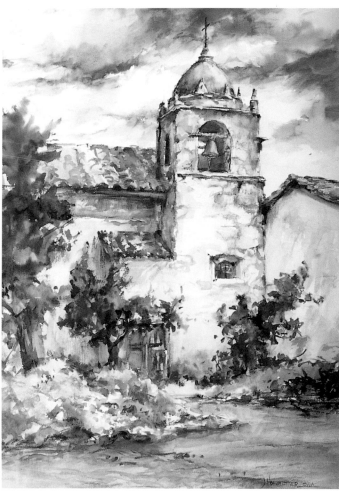

Understated Color

This is a soft and quiet moment at the mission. With all the colors somewhat muted, texture and detail become more important.

Lifting Fog— Early Morning *Transparent watercolor* ~ *28" x 21" (71cm x 53cm)* ~ *Private collection*

Natural Color vs. Interpretive Color

While there is no right or wrong way to handle color, there are principles that will help make color more visually pleasing. The key seems to be a matter of developing color sensitivity—learning to sense how much of a particular color should be used in relation to the others. In the end, artists must follow their own feelings about what is beautiful and what doesn't work. You must complete quite a few paintings to discover even some of the limitless optical, emotional and intellectual potentials of color. It seems that the more you know, the more there is to know.

Mediocre art reproduces natural color in a predictable or photographic way. It is done generally to match the color scheme that the eye sees, often with the subject depicted in all warm or all cool colors. This can result in a pleasant enough description of something, but it leaves little to the imagination or the emotions. Therefore, it is easy to forget.

The eye demands more of the colors in a painting if it is going to be remembered. There must be a dominant color as well as a whole symphony of subordinate colors that are exciting and work together. There should always be some cool color in a dominantly warm painting and vice versa, even if it is only a warm or cool gray. The eye needs the contrast of complements or opposite temperatures playing against each other just as much as it needs dark values against light to be able to read and enjoy a painting.

In short, viewers expect eye-pleasing color changes that go beyond just a photographic statement—even if they aren't consciously aware of the individual techniques at work in the painting. Color must be presented in an unusual and sometimes strikingly original way based on the artist's interpretation. If the artist can't paint a subject's color better than a camera can photograph it, why bother?

Remember this: *Anything can be or become any color.* We know that changing light and atmospheric conditions affect all the local colors anyway, so paint what you feel, not just what you see in a photo. Strongly felt colors painted by the artist can create strongly felt impressions in the viewer. You may try to study all the possible ways to put colors together and try many experiments, but finally, as you paint, your own unique interpretation is what counts.

Interpretive Color

This painting portrays how hard the life of a coyote is and how the animal must constantly forage alone for food, as a group would never get enough to eat. I placed him on a symbol of Mother Nature's paw and hoped she would care for him. I applied a split-complementary color scheme of soft red-violet, red-orange and gray-green. The reference photo actually showed a cold, gray dawn, but I used warmer, more sympathetic colors, with the strongest color and light near the animal.

This painting received an award in the National Forestry Stamp Competition and was exhibited at the Smithsonian American Art Museum.

Dawn Patrol ~ *Transparent watercolor* ~ *18" x 24"*
(46cm x 61cm) ~ *Collection of Wilhelm Klaus*

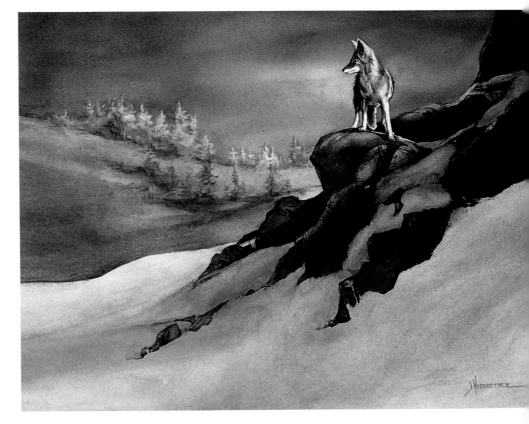

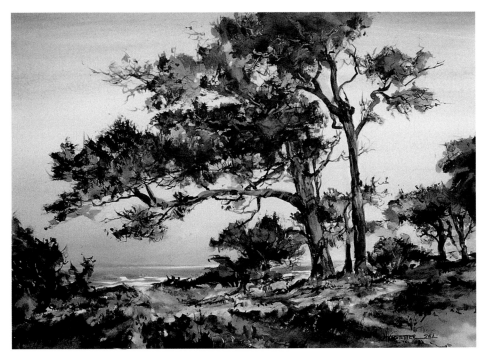

COLOR IN ABSTRACT VS. REALISTIC PAINTINGS

In realistic painting, changes in color can be used to indicate depth; colors become paler and grayer as they recede in space. In abstract painting, however, the artist may prefer a flattened look over a depth-filled one, so you may spot exact repeats of colors in the foreground, middle ground or background of their work. After completing several realistic paintings of a similar subject, something in my nature usually insists on trying an abstract version. I enjoy and learn from both points of view.

Realistic Painting

A delicate use of graded cools to warms is used in the sky to describe the beautiful subtle light of that morning. The water changes from green to blue-gray as it gets lost in the horizon. The trees sit in warm sunlight and cool shadow. Many greens are color searched for the foliage, and the brightest colors gather in the focal area in the lower right.

Morning Light ~ *Transparent watercolor* ~ *21" x 28" (53cm x 71cm)* ~ *Private collection*

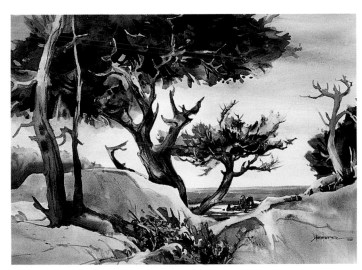

Moving Away From Realism

The sky contains color change and the water's color changes as it approaches the horizon, but here I'm beginning to feel the spirit of the trees—they seem to be strangely dancing as they bend to the coastal winds. The foliage and other shapes seem to look flatter. The values change from light against dark to dark against light, and the colors become more intense.

Wind Dancers ~ *Transparent watercolor* ~ *21" x 29" (53cm x 74cm)* ~ *Collection of the artist*

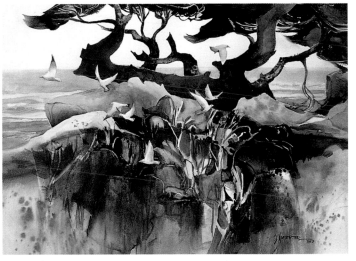

Semi-Abstract Painting

Strong reds and simplified shapes take this painting into semi-abstraction. The tree becomes a tree symbol instead of a real tree. It reads flatly, as do the birds, sky and water. Here, complements and textures can play against each other just for the fun of it. All the shapes speak the same language through their similar rhythms. Notice the angles of the birds, the weeds and the tree branches; all repeat each other, yet they do so differently.

Wild Coast ~ *Transparent watercolor* ~ *21" x 29" (53cm x 74cm)* ~ *Private collection*

Common Color Problems and Solutions

Here are some common color-related problems that many painters face. The next few pages show examples of these problems and suggestions for improvement.

Exact Color or Value Repetition Bores the Eye

The most common problem is the one that my art teacher cruelly pointed out with a big black "X": the lack of color and value changes in large areas. Drastic changes are not always necessary or called for except within the focal area of a painting. Subtle shifts in value and color work for larger, quieter areas. Large areas containing many repetitive shapes require more extensive color searching.

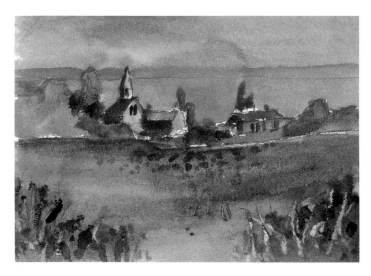

Poor Sketch

This sketch shows no color or value searching in the sky, field and water. The buildings look fine within the focal area, but the large field stands up like a wall rather than stretching into the distance. Lead the viewer's eye into the focal area from the bottom of the painting, and don't decorate corners, which leads the eye out of a painting.

The sky is the color introduction to the rest of the painting, so its colors need to relate to everything else. If there is no blue in the lower half of the painting, then an intense blue sky doesn't work. If there are flowers in the field, paint them first and then add darker colors around them. Avoid tangents, which are created when something ends as it meets the edge or end of something else (for example, when the tops of buildings end on the horizon). These visual tension points trap the eye.

Improved Sketch

With added color and value change, the field now recedes into the distance. The greens in the foreground are quieter than the ones in the back of the field. They progress from cooler midtone values to warmer, lighter and brighter colors and contrasting values, with the most contrast appearing near the buildings in the focal area. Also, the off-center placement of the buildings creates a more exciting focal area.

Plan the big shapes of dark and light first to avoid equal color values throughout the painting. The water now changes from back to front. A higher horizon line, with the water, sky and field all of different-sized shapes, is most pleasing to the eye. The sky is no longer an overall intense blue, but more of a neutral tone that changes from top to bottom, cooler to warmer.

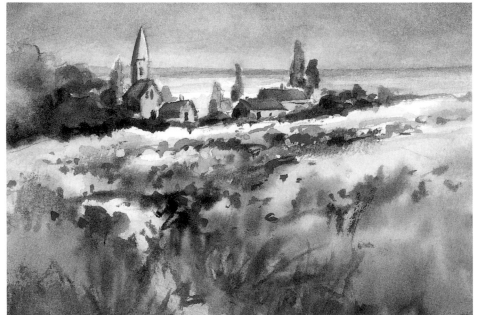

Color Assignments Can Lend an Amateurish Look

Some artists are so interested in drawing the subject correctly that they leave color in the work to be painted from what the mind knows and not from what the eye sees. "Water is blue, tree foliage is light green and dark green, and tree trunks are brown," the mind says. But experienced artists know that even if a photo shows general colors, they must be changed to some extent for a painting to become beautiful, and even more if the artist wishes to convey a sense of atmosphere and depth.

Rarely in nature is anything truly one pure color. The appearance of water, for example, changes depending on the light and reflections falling on it, as well as the surface underneath it. For true color harmony, some of each of the colors chosen for your color scheme should be found to a greater or lesser extent throughout your painting.

The Color Scheme
These sketches are based on a five-color analogous scheme with green as the dominant color and with three subordinate complements.

Poor Sketch
Most of the colors in the color scheme are not used. The trees, water, foliage and meadow don't work together to create good color passage, mood and unity. Without holding onto individualized color identity—integrity of plane—the separate planes get lost and become one. There is no focal area; one needs to be created. The trees are varied in size, but they lack grace and movement. Avoid making a tree line up with the edge of your paper and overlapping the branches in places with foliage. Both are distractions.

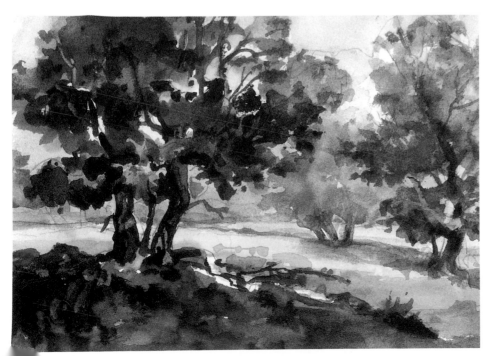

Improved Sketch
This sketch uses all the chosen colors in the scheme. Three separate color planes have been established; the added colors and changing values of the trees, foliage and meadow invite the eye to walk through the painting. To give the illusion of distance with color, each receding plane is slightly grayer, cooler and lighter. Since the water reflects whatever is around it, it too is changed. The focal area (the lower left) is clearly established with the strongest contrast and bright, warm complements. Play with strong dark colors in the foreground shadows if they are in the focal area.

Too Many Intense Colors Give Visual Indigestion

When I teach painting workshops on location in a vivid garden or surrounded by turning autumn trees, it is difficult for the students to use color restraint. However, if every flower in a painting is boldly colored and each tree is screaming for attention, the painting becomes repetitious and uninteresting. Throw some colors into shadow and be selective as you choose which ones will star in the show. Choose the focal area first, and save your boldest colors for that area. The colors in the rest of the painting must all be subordinate.

The Color Scheme
These sketches are based on a five-color analogous scheme with orange as the dominant color and with three subordinate complements.

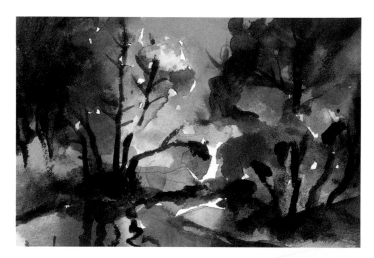

Poor Sketch
I admire those who have the courage to use bright colors in their work. However, if all the analogous colors are equally intense and used against intense complements, the eyes become overwhelmed and find it hard to continue looking at the painting.

Learn to plan quiet places in a painting. Only use the dominant color straight from the tube, and tone down the analogous colors on either side of this color. Always make the focal area the star of the show and avoid turning the spotlight on other areas at the same time. Let the water and sky change from front to back and top to bottom, and watch out for repeats and geometric shapes in the trees.

Improved Sketch
To showcase the autumn colors, mingle together several intense colors in a few focal area trees in the lower left instead of making every single tree intense. Leaving the white of the paper for the water nearest to the intense colors makes the focal area even brighter.

The quieter complementary colors and cool shadows play against the brighter colors. Always play a variety of light, bright shapes against dark, neutral shapes, not an intense color against another intense color. Use similar but somewhat different colors in the various planes. The sky and water change color and value as they approach the horizon. Keep the water reflections quiet to help support the trees as the most detailed focal area. Scrape out lighter branches and let them change color instead of making them all one color and value.

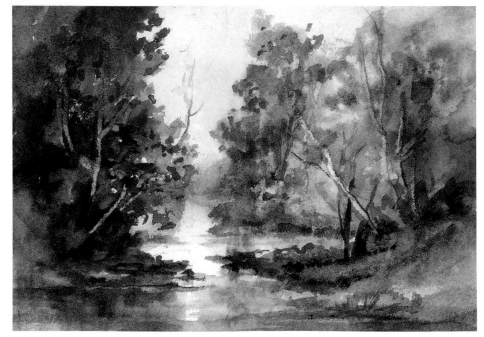

Solving Color Problems That Exist in Photos

I have never found the perfectly colored reference photo, or a scene in nature that needs no alteration. I also know that I would never wish to paint exactly the same colors every day in any of my paintings. It is wonderful how we continue to see and experience subjects differently all the time, and I imagine that is why I will never become bored with painting or teaching art.

Here are a few examples of the color ideas I come up with when I take a photo of something I plan to paint.

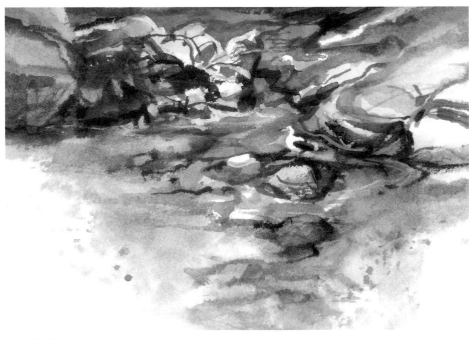

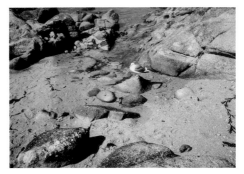

Reference Photo
Sometimes a photo almost works as is, but needs a few changes to work better. Let's simplify this busy photo and look at a few options for adding color interest.

One Option
Let's review the compositional changes first. The focal area, where the bird was sitting, was a little too centered, so I moved it up a bit and to the right. The oval rocks in the lower part of the photo are too similar and geometric, so out they went. I eliminated the seaweed on the right also, as it called attention away from the birds.

A complementary color scheme of dominant blue and complementary orange is a natural fit for this ocean inlet. The focal area (the upper right) needed greater color and value contrast, so I warmed up the rocks a bit there against the cool water and darkened some shadows.

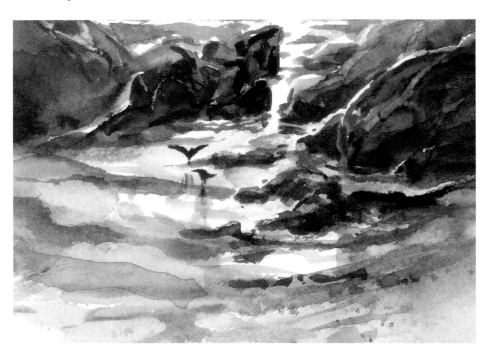

Another Option
The composition is the same as the first sketch, but this time I tried a sunset scene using the complements in reverse: orange as the dominant color and blue as the subordinate complement.

Reference Photo

The sizes and the shadow tones of the flowers are too similar. The flowers are distributed equally in the photo, and the background is all the same dark color and value, which is boring. We need a big dark shape as well as a big light shape, a focal area and more interesting color.

There are many different ways to go, but let's look at two possible color schemes and value approaches for this photo.

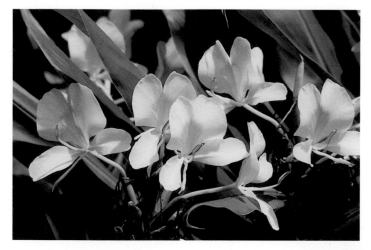

Value Pattern Showing the Lower-Right Focal Area

One Option

Dominant blue-violet is used intensely and in dark values in most of the background, while yellow is used lightly and with less intensity. Always let one complement dominate through its intensity.

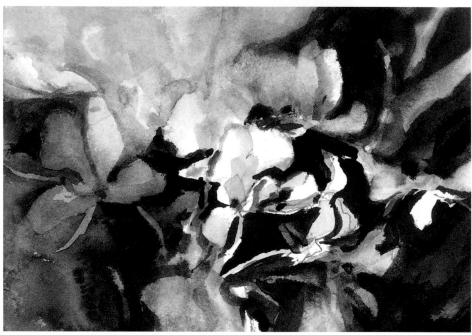

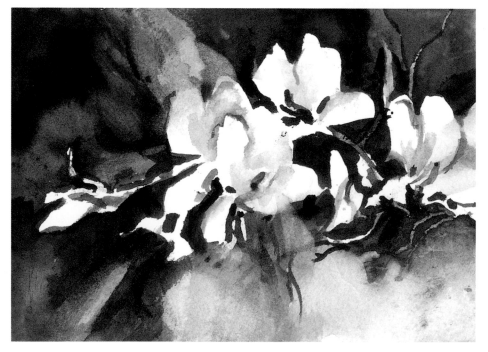

Value Pattern Showing the Upper-Right Focal Area

Another Option

Here, red-violet is dominant and used for most of the background's darker shapes. Yellow-green is used only for accents here and there to enliven the colors through a complement contrast.

SUMMING UP *Color*

Think about color before you start your painting. Some decisions you should make before you begin are:

- **What color will be dominant?** Sometimes when you squint while you view your subject, a color that seems to pervade everything can make its appearance.

- **Where will you use the dominant color?** Will it be a quieter background color in the larger shapes, or will it become the most intense color in and around the focal area?

- **What color scheme will you use?** If you use an analogous color scheme, how many analogous colors including and surrounding the dominant color will you use? Do you want to use the dominant color with its complement, with its split complement, or within a triadic color scheme? Review all the color schemes and then decide. Most importantly, check to see what colors you will *not* use intensely.

- **Will the painting be mostly warm or cool?** One temperature should dominate, though both temperatures can and should be used.

After you begin painting, consider these color questions:

- **Is there too much sameness of color in any shape, or is there a need for more color searching?** Do the colors "talk" to each other because of repeated or bounced bits of color between them? See if you have really color searched your dark areas as well as your light areas.

- **Are the colors more intense and contrasting in the focal area than they are around the edges of the painting?** Have you left the corners quiet in color and detail? Do any of the colors fight or compete with each other? If so, why?

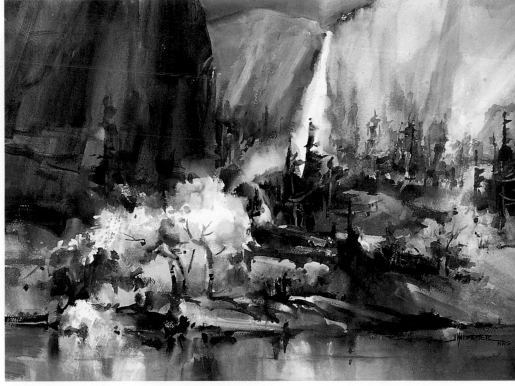

A Split-Complementary Scheme
The cool blue-violets and blue-greens in this scene are a perfect backdrop for the star of the show—the warm oranges of the newly turned autumn trees.

October ~ *Transparent watercolor* ~ *21" x 28" (53cm x 71cm)* ~ *Collection of the artist*

As you near the end of the painting, ask yourself these questions:

- **Would a few warm or cool grays help play up the intense colors better than their complements do?** Shadows are an easy place to add these colorful but not overpowering grays.

- **Are the final colors interesting and a little unusual in some way?** Think memorable color, not predictable or photographic color.

- **Aside from the colors, do the values work?** Use colored cellophane or squint to see whether the values are what they should be. Can the eye move easily through the lights and darks of the painting?

- **Does the painting have integrity of plane?** Do the foreground, middle ground and background all have colors unique to them?

- **Have you successfully avoided "color-assignment syndrome"?** Be sure that there are a variety of colors in each object. For instance, tree trunks reflect the other colors that exist around them, as do shadows.

- **Would some additional glazes help?** A glaze of color can connect disparate parts, intensify the focal area or subdue supporting areas.

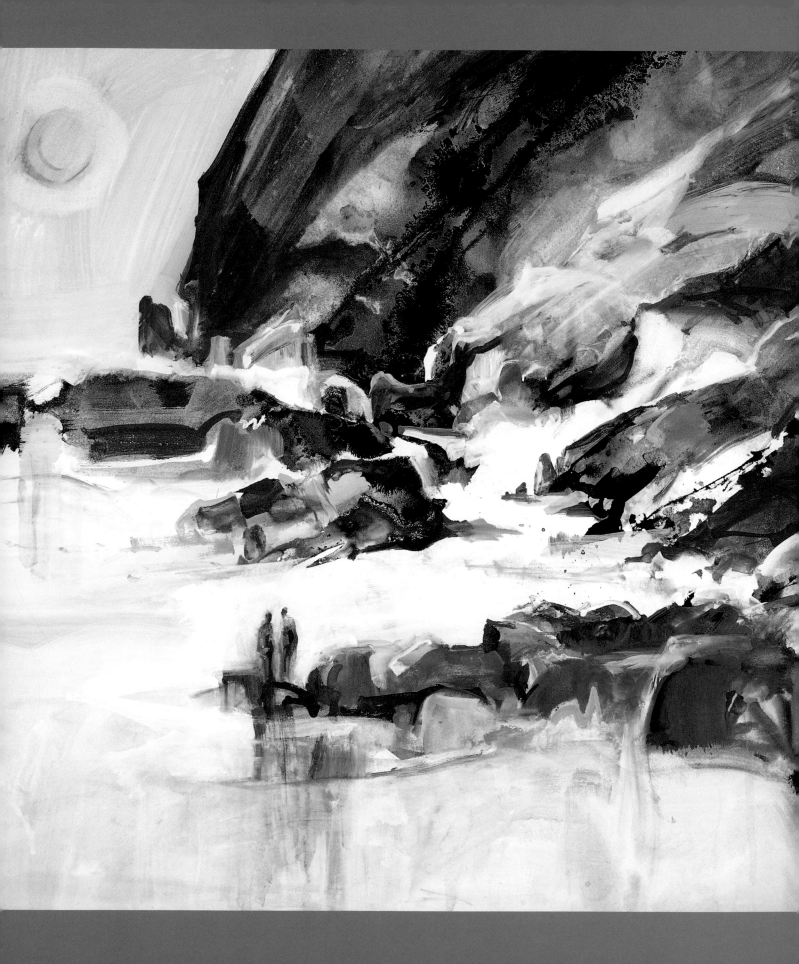

5 *Design*

> *Irregular shapes that*
> *Have good design*
> *Lie under our work*
> *And make it shine.*

Design works like the brain in our artistic body. When we refer to good design principles, we find out how to solve the various painting problems that arise each time we start a painting. Going back and using what we have learned about design can strengthen our work tremendously. The previous chapters dealt with the structures of composition and color, which are among the building blocks of design. Now let's organize what you have learned and combine it with powerful new information about what really makes a painting work.

Explore the wonderful formulas that add magic to paintings, and learn exciting shortcuts to powerful design arrangement that the beginning artist knows little or nothing about. Identify the basic elements of a painting, and then discover ways to make those elements say what you want. Once you thoroughly understand these successful design formulas, this information will flow naturally from your brain to your hand as you paint. My students tell me that after working hard with these design principles, they gain the artistic freedom to produce good paintings that sell quickly and win awards. Don't expect to be able to digest all of this information at once; it usually takes awhile to assimilate ideas well enough to use them properly. After a time, though, it will become instinctive.

A Good Painting Begins With a Strong Design
This semi-abstract painting has a cantilever design arrangement (see page 90).

Summer Coast ~ Watercolor and graphic white ~ 21" x 29" (53cm x 74cm) ~ Collection of the artist

The Elements and Principles of Design

Many of the elements of design—shape, value, size, color, direction, line and texture—you are already familiar with. They are the building blocks of your painting. Your ability to organize the elements in an eye-pleasing way instead of a haphazard manner is governed by the principles of design—unity, conflict, dominance, repetition with variety, movement with gradation, and balance. Without considering these principles, the attractive elements in your painting might not work well together to express your intended statement.

Let's review the elements of design and take a closer look at the six principles.

THE ELEMENTS

Consider the elements of design the ingredients of your painting:

- **Shape.** Make them irregular, and avoid boring perfect geometric shapes.

- **Value.** Use the darkest and lightest values in the focal area and less contrast in the large areas.

- **Size.** Have a variety of big, medium and small shapes.

- **Color.** Don't go more than an inch or two (3cm to 5cm) without some change. Never exactly repeat the same colors.

- **Direction.** The emphasis can be horizontal, vertical, curved or diagonal.

- **Line.** Practice using a variety of lines and edges: thick to thin, broken to solid, lost to found.

- **Texture.** Use it sparingly and irregularly, and merely suggest texture instead of overdoing it.

THE PRINCIPLES

The principles of design are like the recipes you use to combine the ingredients, the elements of design.

- **Unity.** Make all parts of the painting speak the same language for a quality of oneness. Try to have one part introduce the next as the eye moves through the painting. Just remember that unity or sameness can be boring without some conflict or variety.

- **Conflict.** Create a little tension and excitement with opposites—strong contrasts of value, color, direction and so on. However, be careful not to overdo it!

- **Dominance.** Avoid fifty-fifty divisions. Know which element or elements should dominate, and push it! But remember, the stronger you push, the stronger the mood.

- **Repetition with variety.** The eye can instantly spot duplicates and become bored. However, repeats and rhythms are delightful in a painting if they are not exactly the same. All of the elements can be repeated endlessly with variety.

- **Movement with gradation.** Direct the eye comfortably through the painting with any of the seven elements, using gradation to enliven the passages and add depth. Know where the focal area is before you make decisions on how to move the eye.

- **Balance.** Imbalance is uncomfortable, so trust your feelings when evaluating the balance in a painting. Formal or symmetrical balance can be boring, but informal or asymmetrical balance is visually pleasing. View your painting upside down or in a mirror to check for good balance.

Applying the Elements

Before you can follow the recipe, you have to be familiar with the ingredients. Let's see how each element of design can be applied for the best results. Notice that it's nearly impossible to talk about one element without mentioning another or to mention proper use of an element without a principle coming into play. This demonstrates how naturally these elements and principles can work together once we understand how to use them.

Shape

Shape is one of the first eye-catchers in a painting. Chapter one discussed the importance of having a variety of dark and light shapes and avoiding boring geometric shapes. It is also important to let the shapes introduce each other and speak the same language. This shows up most often in the edges of a shape as well as the related colors and textures. Lastly, the negative or background shapes in a painting should be as exciting as the positive shapes. Variety is the key to handsome shapes.

Value

The dark and light values in a painting can attract or deter viewers. They might hurry from across a room to get a better look if the values are varied, well placed and dramatic. They can lose interest if the painting seems to use only one value.

First choose the dominant value: light or dark. Then arrange your light and dark shapes into connected overall shapes that lead the eye to the focal area, which should contain the greatest amount of value contrast. Use gradation within the various value shapes to keep them interesting.

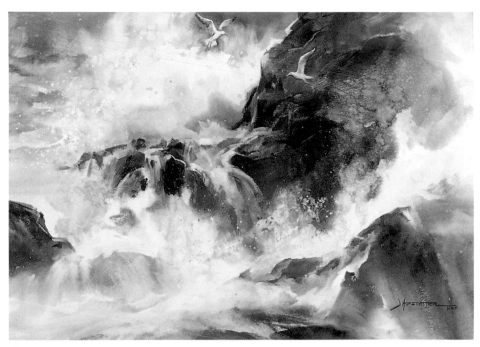

Shape
Notice how the edges of each shape change from lost to found. There are no divorces going on as each shape talks to the other with its color, texture and general appearance, yet each shape is unique unto itself.

Stormy Surf ~ *Watercolor and graphic white* ~ *21" x 28" (53cm x 71cm)* ~ *Collection of the artist*

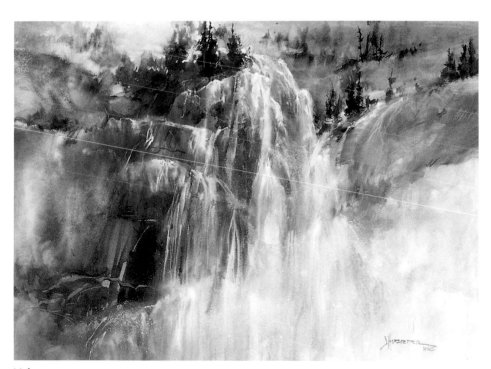

Value
This painting's emphasis is on value and texture, while color plays a minimal role. The light values dominate the darks.

Frozen Cascade ~ *Watercolor and graphic white* ~ *21" x 28" (53cm x 71cm)* ~ *Collection of the artist*

Size

To look interesting, the parts of the painting must vary in size. The eye will quickly spot any exact duplicates. Size relates to all the elements in the painting. Texture, color, line and so on must vary in quantity and arrangement, so as to never repeat exactly. Usually the larger, simpler pieces join up with the outside edges; the smaller, more irregular ones are within the focal area.

The largest size or quantity of an element determines the dominance of a painting. Select in advance the element or elements you wish to fulfill this role. Elements that are not dominant should be played down.

Color

Color is very personal, as we all see and feel it differently. If you choose color to be the dominant element in a painting, predetermine the color scheme, then develop great amounts of color change and gradation as you paint. Be sure to get the values of the color correct. Practice mixing and matching colors. Think about using cools or grayed colors to play against the brightest ones. Make the most exciting color statement in the focal area.

Size

Size plays a large role in establishing the scale and depth within this painting. The tiny cars travelling across (and the small boats sailing underneath) the bridge lend a massive feel to it, though the structures of the bridge appropriately diminish in size in the distance. The variation of size within the foreground rocks and foliage keeps this area from being boring.

Golden Gate ~ Transparent watercolor ~ 29" x 21" (74cm x 53cm) ~ Private collection

Color

Color is the dominant element in this sunset painting. This scene shows a different approach to emphasizing the focal area with color. Instead of the focal area containing the brightest colors, these colors *surround* the focal area. The brilliant, strong gradation of sky colors frames the focal area's quieter colors for a dramatic scene.

Mont-Saint-Michel, Sunset ~ Transparent watercolor ~ 21" x 28" (53cm x 71cm) ~ Collection of Glen and Mila Hofstetter

Direction

There are four directional movements possible in a painting: horizontal, vertical, circular or curvilinear, and diagonal or oblique. A well-designed painting is dominated by only one of these. The other directions can be used to a lesser extent, but it is best to select the dominant direction as you plan the dark and light shapes in the preliminary thumbnail and stay with it.

Line

This element is the oldest known form of art. The lines found in ancient cave art are among the most beautiful and expressive. Lines should follow the dominance of direction and constantly change so as not to become redundant. As you add lines to your painting, think broken to solid, uniform to irregular, thick to thin, dark to light, soft to hard, and warm to cool; doing this will give you an eye-pleasing dominant group of lines.

Lines can border shapes or be beautiful calligraphic expressions of texture or writing in a painting. Be careful not to overdo your linework, however, as it can make a painting look cluttered and busy without some simple areas of rest.

Direction
Strong diagonal lines and shapes are used here to direct the eye to the focal area (lower left).

High Horizons ~ *Transparent watercolor* ~ *21" x 28" (53cm x 71cm)* ~ *Private collection*

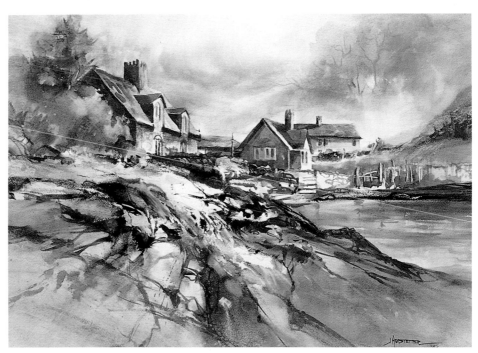

Line
Black waterproof ink and watercolors were used to create this painting, in which the element of line is dominant. This type of ink makes interesting darks when mixed with watercolor and creates irregular lines on partly wet paper. It works well to describe rock lines and textures.

Living Beside the Loch ~ *Watercolor and ink* ~ *21" x 29" (53cm x 74cm)* ~ *Private collection*

Texture

Of the seven elements, texture is perhaps the least important. It is, however, useful in describing a surface as well as enriching and increasing its weight. Texture is used most often in the focal area to give further description and importance to that part of the painting.

Amateur artists often wish to paint every leaf on a tree because they see all the leaves. Advanced artists use the fewest leaves they can get by with to describe the silhouette of the tree. Too much texture makes a painting superficially decorated instead of well designed.

Many good paintings have been ruined because of a painter's need to tickle the subject to death with small brushstrokes. Texture is best used in various-sized sections and irregularly, usually to enrich a large bland area. I have found that texture most successfully enriches a painting when the color is very muted. Andrew Wyeth is a master of this.

Texture

In this painting, the existing textures are kept to a minimum to allow the color and magic of a summer day to shine forth. Notice how the eye can move toward and away from the light figure without getting stuck in a bull's-eye situation. Texture keeps the focus within the painting and away from the edges and corners.

July Garden ~ Transparent watercolor ~ 21" x 28" (53cm x 71cm) ~ Private collection

Exercising the Principles

Exciting design shows only the best parts of a scene or subject with interesting variety, rhythm and stunning poetry woven throughout rather than showing the subject only as a camera could report it. Exciting design happens when artists learn and interpret the principles of design and apply them to the elements in their paintings. Let's study how this can occur.

Unity

Unity is the most important of all the design principles because it takes just a glance to see if everything in a painting is working together. All of the strongly emphasized elements must be echoed but always a little differently. For example, a painting that has tones of blue on only one side is not unified. While the artist's technique—such as a calligraphic style or a pointillist brushstroke— can bring everything together, unity usually is due to a certain feeling generated by the concept behind the painting that pervades each shape and detail. You may need to pre-select whatever you will strengthen or emphasize in the painting and then stay with these ideas throughout the painting's development.

Conflict

Two opposing versions of an element provide conflict: a soft, straight horizontal edge against a hard, jagged diagonal one; a strong orange against a blue-gray; a large light shape against a smaller dark one. Conflict prevents boredom. How much conflict is necessary? A field of poppies probably needs some conflict to hold the viewer's attention. Do you add an interesting tree, a few figures? To decide, ask yourself why you wish to paint the field. How can you make the mood stronger without destroying your main idea? Where do you want the focal area to be, and how can you increase the drama there?

Unity

My main goal was to make the house "gingerbread", the flowers and the foliage speak the same language. To help accomplish this I bounced similar warms and cools in the shadows.

Gingerbread and Hollyhocks ~ *Transparent watercolor* ~ *21" x 28" (53cm x 71cm)* ~ *Private collection*

Conflict

To depict the "walking thunder," I felt it important to create great drama and contrast between the stormy sky and the land. I set up a cool sky against the warm land with soft, curved clouds playing against the hard, angular shapes of the buttes.

Walking Thunder ~ *Transparent watercolor* ~ *21" x 29" (53cm x 74cm)* ~ *Private collection*

Dominance

Dominance is key to the success of any painting. Total equality in a painting equals total visual frustration. The eye will not linger where there is no order or hierarchy, only chaos. Most paintings can succeed with two or three elements being dominant. Decide first which elements you wish to emphasize and where. Then make them do one or more of the following:

- Show the greatest amount of contrast.

- Be the largest element or cover the most area.

- Repeat a lot with subtle changes each time.

- Be the strongest color or the brightest.

Repetition With Variety

Repetition is a way to connect the various parts of a painting, bringing a sense of unity to the composition. Each repeat must differ enough from the others so that the repetition is not too predictable. Choose two to four elements to repeat throughout the painting. Then test your imagination and make these repeats only similar. Repetition without exact duplication gives beautiful rhythm to your work and can echo the motif of the painting in various ways.

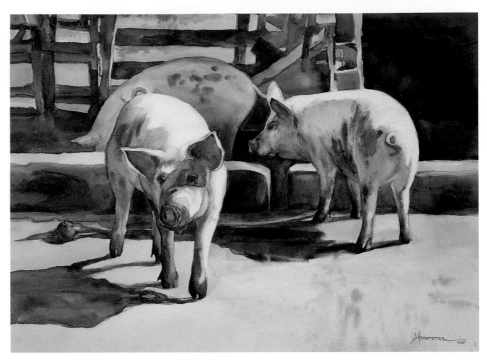

Dominance

The curved shapes in this painting dominate the horizontal and vertical shapes in the background. The cools dominate the warms, but notice how all the colors bounce into each other a little for variety. See how the warm ground color bounces off of the pigs' bellies?

Piggy Backs ~ *Transparent watercolor* ~ *21" x 28" (53cm x 71cm)* ~ *Private collection*

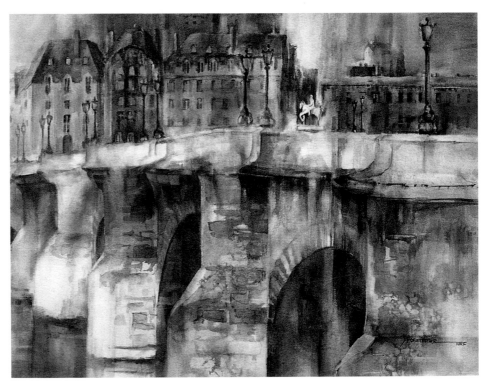

Repetition With Variety

In this painting I chose to repeat size, texture, color temperature and direction. Each of the repeated vertical bridge spans is a different width. Different eras of civilization added various-sized rocks to the bridge, which provided various repeated textures for me to choose from. The color consists of repeats of warm against cool. Lastly, the direction is a strong horizontal going back in space, with varied repeats in the verticals of the buildings bringing us to the focal area at the upper right.

Paris, Le Pont Neuf ~ *Transparent watercolor* ~ *21" x 28" (53cm x 71cm)* ~ *Courtesy of Christopher Queen Galleries*

Movement With Gradation

The eye usually enters a painting at the bottom or from a side. It moves along the lights if the painting contains mostly dark values and along the darks if light values dominate. The eye then moves around the painting until it comes to the focal area, where it stops to enjoy this most exciting part. It will return again and again to this area via the visual path the artist has provided.

Gradation is one way to guide the eye around a painting. Gradual change from large to small, dark to light, warm to cool, thick to thin, hard edges to soft edges and so on will carry the eye through the painting on the path you set.

Balance

Balance happens when forces that oppose each other are equal. In painting, formal balance involves using equal divisions of space and equal amounts of shapes. Because this predictability can be very boring, many artists prefer informal balance. Think of a seesaw: the heaviest weight on one side must be near the center to balance the lighter weight on the opposite end. One way to achieve informal balance in a painting is by placing a big light shape opposite a small dark shape.

If you feel an imbalance occurring in your painting but can't put your finger on it, try viewing your work upside down or in a hand mirror as you look at it over your shoulder to gain a different perspective. Add weight to an area in need by trying some of the following solutions:

- Darken the area.

- Create more value contrast within the area.

- Add more intense color to the area.

- Add irregular pattern or detail to the area.

Whatever you decide, be sure that the weight you are adding does not overpower the painting or detract from the focal area (if the area you are adding the weight to is not within the focal area).

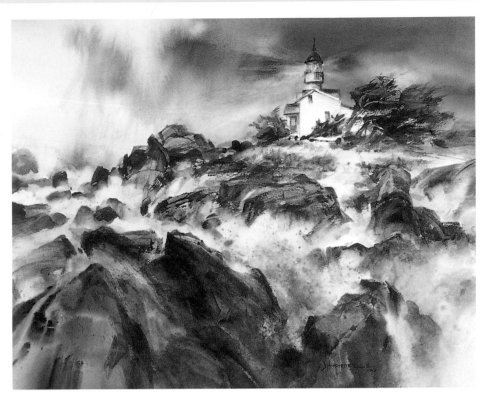

Movement With Gradation

In this painting, gradation in size moves the eye around and back into the distance. The rocks diminish in size leading back to the lighthouse, as does the heavy white surf coming from the left to the right. The viewer's eyes move from the lower right to the upper left, then to the focal area, and then back again on the light paths in this mostly low-key painting.

Point Pinos Light, Winter Storm ~ *Transparent watercolor* ~ *21" x 29" (53cm x 74cm)* ~ *Collection of the artist*

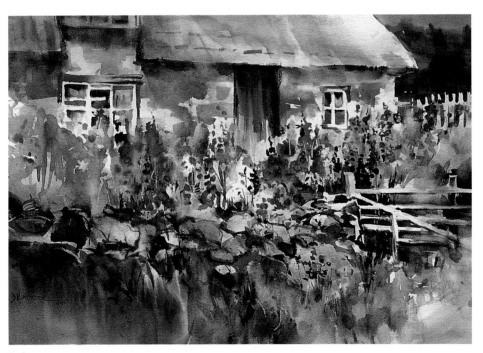

Balance

The building's off-center location and the placement of the focal area in the upper right maintain the balance of the piece. Most paintings use this kind of informal balance.

Yorkshire Cottage ~ *Transparent watercolor* ~ *21" x 29" (53cm x 74cm)* ~ *Collection of Lee and Diane Brandenburg*

Putting It All Together

At first, the elements and principles of design may seem like a lot to take in, but after awhile you will subconsciously consider them as you work. The following examples show how the principles and elements work together in individual paintings.

Irregular foliage shapes with similar edges help to create a feeling of unity throughout the painting.

Directional dominance is present with curvilinear tree shapes; the roof curves also. The subordinate verticals and horizontals of the tea house create interesting conflict.

The foliage shapes repeat with variety, and none are exact duplicates.

The warmer greens in the foreground gradate to cooler greens in the background.

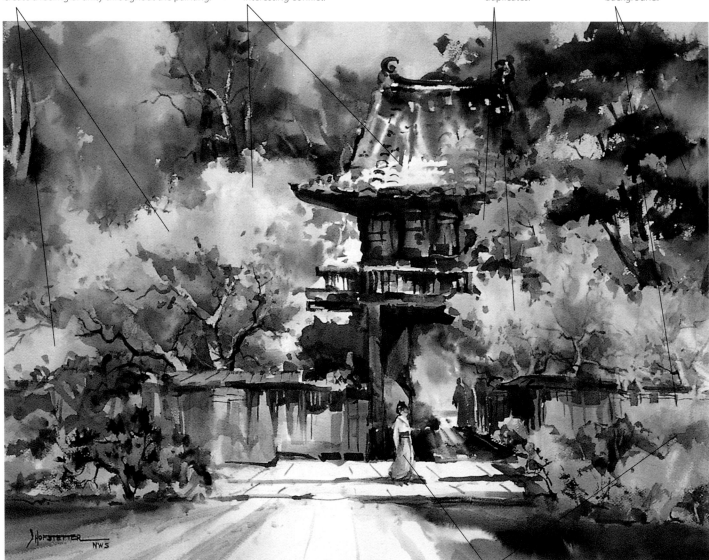

Oriental Tea House ~ Transparent watercolor ~ 21" x 29" (53cm x 74cm) ~ Private collection

The eye can easily move through the lights and the darks without getting stuck anywhere.

Textures are soft around the outer edges of the painting and gradually become stronger as they move toward the focal area, where a figure is located in the eye of the rectangle.

The big, simple water shape on the left helps to balance the active right side.

Gradation in the water gives the painting depth.

Repeating verticals dominate, with slight curved and diagonal variety for conflict and interest. The horizontal band at the top holds the vertical masts in place.

Harbor ~ *Transparent watercolor* ~ *21" x 28" (53cm x 71cm)* ~ *Collection of the artist*

Dominant cools are supplemented by some warms for conflict.

Cools and warms bouncing into the white shapes create even more repetition with variety.

Repeats of the white shapes on the boats are never the same size.

Powerful Compositional Arrangements

There are countless design structures that can make your paintings more exciting, but there's not enough space in this book to show them all. Many Renaissance painters used triangular, spiral, circular or S-shaped design plans as foundations on which to build their complicated compositions.

On the following pages I diagram and discuss the ones that have been particularly useful to me through the years. They can be used individually or in combination or with your own arrangements. Many letters of the alphabet work as design structures. Don't be afraid to experiment.

Horizontal Painting

Here, the white snow patterns in the focal area (upper right) create an irregular vertical. To avoid a boring straight line, break up the horizon line a little and continue to develop big, medium and small dark and light shapes for balance and visual enjoyment. In a limited-color painting, texture can be the star of the show.

Early March ~ Mixed media ~ 22" x 28" (56cm x 71cm) ~ Private collection

Horizontal Arrangement

A strong horizontal subject in a horizontal format needs a vertical stopping point somewhere to break up the side-to-side eye movement. This is usually placed off center, with dark and light value contrasts.

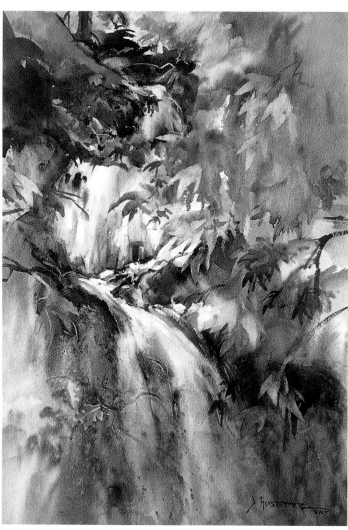

Vertical Painting

A vertical subject is enhanced with a vertical format. Notice how the focal area (upper left) contains the brightest color, the greatest contrast and two short horizontals. A variety of diagonal shapes in the falls and leaves dominate, as does bright, warm color.

Hakone Falls ~ Transparent watercolor ~ 28" x 21" (71cm x 53cm) ~ Collection of the artist

Vertical Arrangement

A horizontal placed somewhere in the vertical thrust is necessary to interest the eye. This is usually where the focal area belongs.

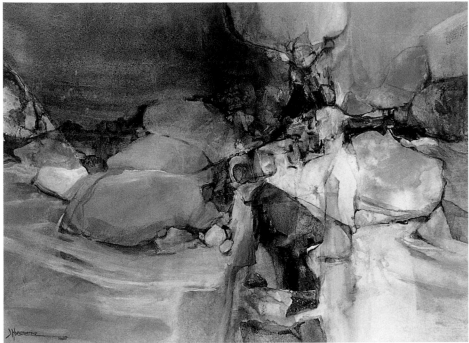

Cruciform Arrangement

This is a combination of the horizontal and vertical design arrangements, positioned in an off-center cross-composition. Each corner shape is usually a different size.

Cruciform Painting

The eye needs to move from corner to corner through the cross of the horizontal and vertical. If the corner shapes are light, place some small light shapes at the center of the cross so the eye can easily travel through it. If the corner shapes are dark, place small dark shapes. The off-center focal area always includes the intersection.

Tidal Patterns ~ *Watercolor and collage* ~ *21" x 28" (53cm x 71cm)* ~ *Collection of the Triton Museum of Art*

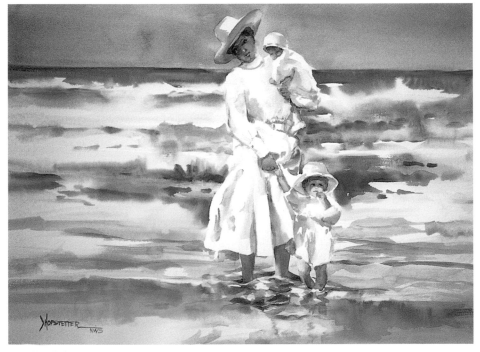

Axial Hold Arrangement

A high horizontal shape is connected to the top and a little to the sides of the composition with middle or darker values. The contrasting-valued subject is held in place against this, and it hangs down below this strip. The subject does not need to touch the bottom of the painting.

Axial Hold Painting

Make sure that the subject or group of subjects is off center or that there is an irregular spacing along them for interest. This arrangement also will work for a vignette; this works best when each corner has a different amount of white and the subject touches the edges of the paper slightly in at least two places.

Yesterday's Holiday ~ *Transparent watercolor* ~ *21" x 28" (53cm x 71cm)* ~ *Collection of Dr. Frank and Mrs. Pamela Pinkner*

Radial Arrangement

Diagonal shape movements radiate from the off-center focal area in this design structure.

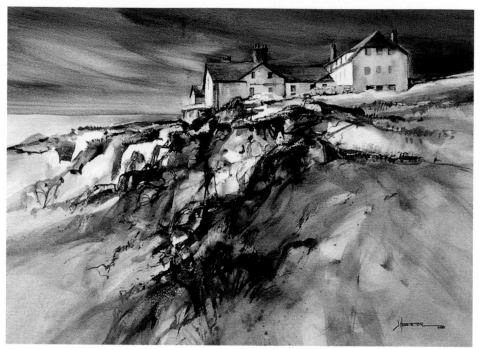

Radial Painting

With strong use of diagonals, this is the most dramatic of all the compositions and is wonderful for large or vast landscapes. Be sure to use a variety of sizes in the dark and light shapes that will lead the eye to the focal area, where all the lines and shapes converge.

Land's End, Cornwall ~ Watercolor and India ink ~ 21" x 28" (53cm x 71cm) ~ Private collection

Cantilever Arrangement

A cantilever is a projection coming off a strong support system (think of it as a porch extending from a house). The heavy mass (or house) that the projection (or porch) extends from must be strong enough to provide a well-balanced feeling where the focal area is hanging out in space.

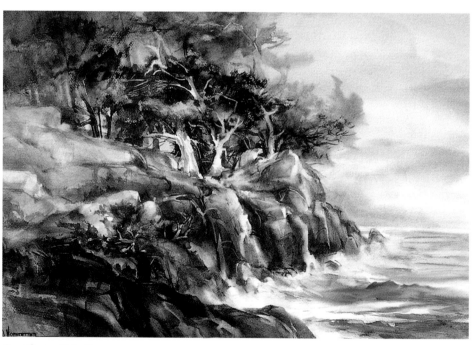

Cantilever Painting

Notice in this painting how each plane of land is a different value. The water changes from front to back and the sky changes from top to bottom, helping to give depth and variety to this cantilever structure.

Monterey Coastline ~ Transparent watercolor ~ 21" x 28" (53cm x 71cm) ~ Private collection

Quick Ways to Make Your Composition Exciting

Another easy method to improve the look of a painting's composition focuses on general organization. Three organization techniques include wedging, bridging and interlocking.

POORLY ORGANIZED

WELL ORGANIZED

Wedging

Using various-sized, somewhat triangular wedge shapes that have an opening of contrasting value between them move the eye gradually back in space. This will lead the eye in a slow, rhythmic zigzag to a focal area in the upper left or right of a painting. The eye moves on value contrast or edge interest. This works especially well to remedy a painting with a large empty or boring foreground.

POORLY ORGANIZED

WELL ORGANIZED

Bridging

This technique anchors a floating subject to the edges of the painting for a more stable appearance. Bridging works well on a high- or low-horizon painting. Create these bridges or arms in unequal lengths and widths. They can anchor the subject from the focal area to the edges on either side and possibly to the top and/or bottom. Be sure the negative corner spaces you create vary in size.

POORLY ORGANIZED

WELL ORGANIZED

Interlocking

Shapes in paintings work best if they interlock by means of irregular edges, weaving in and out, and overlapping in places, similar to a jigsaw puzzle. If the shapes don't move across the center of the painting and intermingle, they are apt to make the work look like separate halves instead of one unified painting. As with the other organization techniques, make sure your shape sizes vary.

Try On Multiple Design Plans

There is always more than one feasible design plan for any given subject. Increase your inherent design abilities by creating a variety of "scaffoldings" for your sketches. Sometimes the most obvious choice, usually the first one that comes to your mind, isn't the best choice. Many of my students who have become frequent award winners try several different arrangement sketches before deciding on the best overall design for a final painting. To select one over the other, choose the arrangement that seems to capture the mood or feeling of the subject the best, or select the one that was the most fun to create.

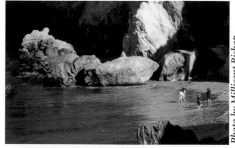

Reference Photo
Here is a photo of Pismo Beach. Let's create a couple of possible compositions based on this scene.

A Dominantly Horizontal Arrangement With Some Cruciform Added
This composition applies strong horizontal movement in the rocks. The figures are placed off-center, creating a vertical movement from the light rock at the top to the reflections below.

A Cantilever Arrangement
The eye-catching figures are used this time in the lower left, with a massive upper-right area of rock to anchor them.

TURN THE ORDINARY INTO THE EXTRAORDINARY

One of my best art teachers, Millard Sheets, used to say that good artists should be able to use whatever they find along any roadside—old gum wrappers, weeds, anything—and paint marvelous works of art simply by using strong design scaffolding under the subject.

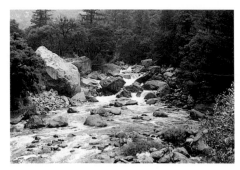

Reference Photo

White water and dark rocks can be used in many design arrangements. Any of the following options are exciting to the eye.

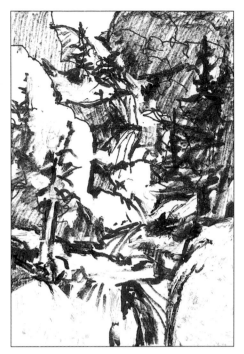

A Vertical Arrangement of an Isolated Section

Rocks and water can be turned into a waterfall by exaggerating the vertical shapes of dark and light. The vertical trees add to the vertical emphasis.

A Radial Arrangement

In this arrangement, the sky, water, trees and rocks in the upper right form the nucleus to which all the lines and shapes of the composition point.

An Axial Hold Arrangement

The dark water at the top holds in place the light rocks and water below it.

CHOOSING *and* EXECUTING A DESIGN PLAN

MATERIALS

SURFACE

- 300-lb. (640gsm) rough watercolor paper

WATERCOLORS

- **Transparent colors:** Blue Green, Carbazole Violet, Cobalt Blue Tint, Green Gold, Indanthrone Blue, Indian Yellow, Orange Lake, Permanent Magenta, Permanent Rose, Rose Dore, Sap Green, Transparent Yellow

- **Transparent earth colors:** Permanent Brown, Quinacridone Burnt Orange, Quinacridone Gold, Quinacridone Sienna

BRUSHES

- **Slant-edge flats:** 1¹/₂-inch (38mm), 1-inch (25mm), ¹/₂-inch (12mm) and ¹/₄-inch (6mm)

- **Rounds:** nos. 5 and 8

- **Oil bristle flat:** ¹/₂-inch (12mm), for softening edges

- Some inexpensive smaller brushes, for applying masking

OTHER

- Silver pencil and white plastic eraser
- Masking fluid
- Small bar of soap
- Crepe lifter
- Small, flat elephant-ear sponges
- Fine-mist spray bottle
- Tracing paper (optional)
- Graphite paper (optional)

For this lovely autumn scene we'll try a couple of different design arrangements.

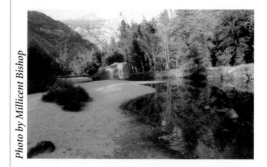

Photo by Millicent Bishop

Reference Photo

This photo is lovely from a design standpoint. The only change necessary is to eliminate the rock in the lower-left corner so that the corners don't distract the viewer from the focal area of the painting. However, let's try two different compositional arrangements.

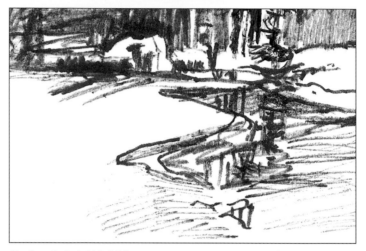

Option 1: Axial Hold Arrangement

After cropping the top of the photo, we establish a strong, dark horizontal band. The remaining lighter, brighter subject material reads nicely against this and connects to the darker shape of the water. This arrangement could be good to work from.

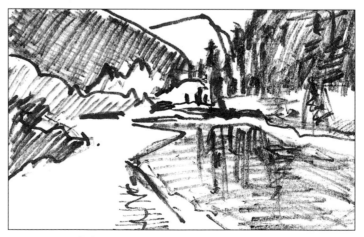

Option 2: Radial Arrangement

The dominantly diagonal shapes in the photo invite the eye to move to the focal area (upper right). The secondary vertical tree reflections lead there also. Even the mountain drops down to the focal area. This sketch is better for this demonstration because it seems to more completely convey the feeling of the place and the season.

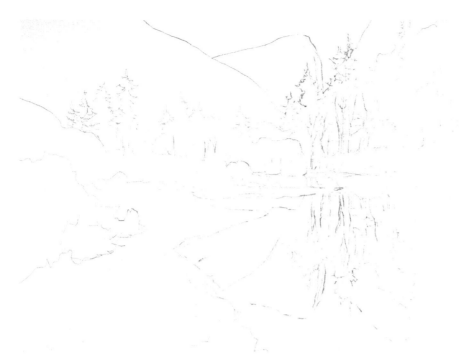

1 **Make a Drawing and Apply Masking**
As you draw your subject in pencil, make sure all the trees and other items are of different heights, widths, spacing and so on. Be sure that the focal area (upper right) is the most interesting part of the painting. If you find that drawing mirror images for the reflections of the trees and other material is difficult, draw the top area on a piece of tracing paper. Flip it at the water's edge, then lightly tape it to the paper with a sheet of graphite paper underneath. Then draw it all upside down. Sometimes a mirror is helpful also.

Mask the sky and all parts of the painting that will be white or of the lightest values. Apply the masking fluid carefully, as this will give you less to correct later. (Look at step three to see where I applied masking.)

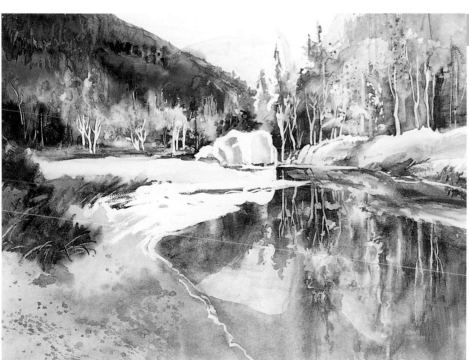

2 **Lay In the Scene Wet Into Wet**
This purely transparent watercolor piece uses the dominant color yellow-orange with red-orange, orange, yellow and yellow-green as the four accompanying colors. Blue-violet is the complement, with some blue and violet also. All the earth colors can be used as well for this autumn scene.

Work quickly from the top to the bottom of the painting. Spray lightly with the fine-mist spray bottle to wet an area before you paint it, especially when you're working on the water reflections. Be sure not to paint the water part until the landscape that will be reflected in it is painted.

When working wet into wet, use thicker paint without too much water on the brush so your paint will dry dark enough the first time around, giving you the correct values. Keep changing colors and values as you brush on the paint so as to always please the eye.

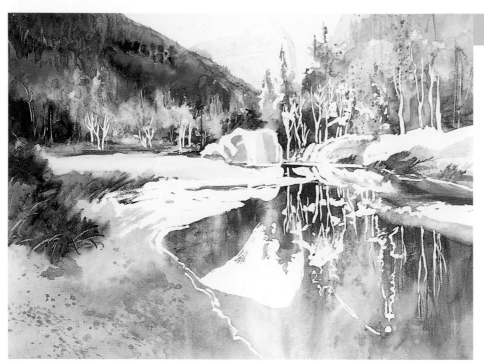

3 Remove the Masking

Remove the masking fluid when the paper is completely dry. The whites may look rather raw and disjointed from the painting. You can fix this in the next step.

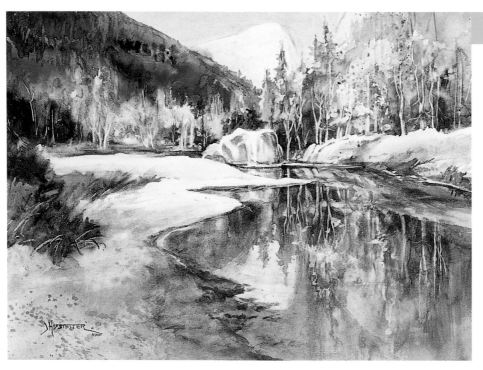

4 Soften and Touch Up Masked Areas and Final Details

Use a small, flat bristle brush to soften hard edges left from the masking fluid. If the bristles are too long, cut them straight across until the bristles are no more than one-half inch (12mm) long. Wet the bristle brush with water and soften any edge that looks too raw. The brush will pull surrounding color into the whites to tie them in with the painting colorwise. Blot it with a tissue if you want the area to be lighter, and add more color if necessary.

Paint some more darks at the water's lower edge. Paint the sky, keeping it simple and light, and soften the tree trunks on the left side of the painting. As you finish the water, bear in mind that the reflections often are a little darker and greener than the objects being reflected.

Autumn Reflections ~ Transparent watercolor ~ 21" x 29" (53cm x 74cm) ~ Collection of the artist

SUMMING UP *Design*

Ask yourself these important design questions before you begin your painting *and* as you continue working on it:

- Which design arrangement best suits what I want to say about the scene?

- Where is the biggest shape in the painting going to be? What value is it, dark or light?

- Where is the focal area going to be?

- Does my thumbnail sketch show big, medium and small shapes of dark and light?

- Have I planned some conflict, color and value contrast, and detail variety to lend excitement where I want it?

- Does the painting have some repetitive elements, repeated each time a little differently?

- Do the shapes relate in some way to each other, with each seeming to introduce the next?

- Will my edges be mostly hard or soft? Where does the scene go out of focus? Are the corners uncluttered?

- Where are the simple areas that allow the complex ones to be the focus?

- Have I checked to be sure there are no fifty-fifty divisions of shape, value, color or any other element in my painting?

- Have I included large solid lines along with smaller broken ones?

- Is too much small contrast making the scene too busy? Where can I simplify?

- Do I have just one main idea throughout? Does it have a consistent realistic or abstract handling?

- Does the painting feel balanced? Have I looked at it in a mirror?

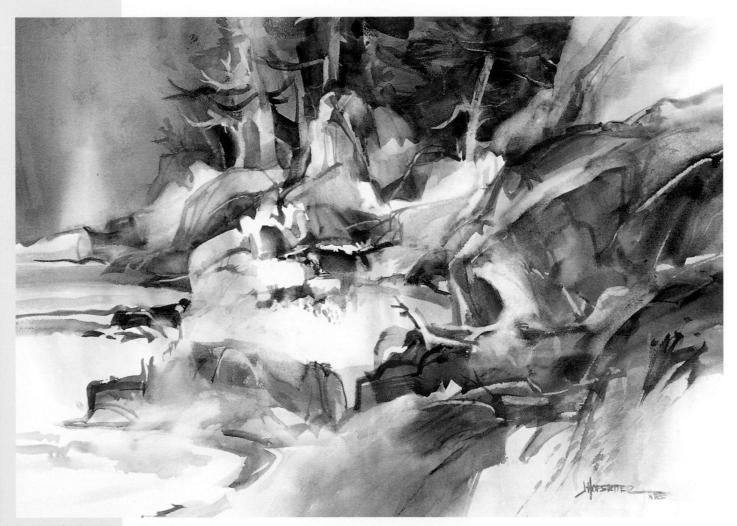

Try Combining Design Arrangements
This painting combines radial and cantilever arrangements. The rocks, trees and water all direct the viewer to the focal area (upper left), which is held in place by the strong cliff coming down from the upper right.

North Shore ~ *Transparent watercolor* ~ *21" x 29" (53cm x 74cm)* ~ *Collection of the artist*

6 The Golden Mean

To please the eye

Use the Golden Mean.

The 3:5 ratio

Will often be seen.

The Golden Mean proportion or spacing that is used in art is beautiful. The Golden Mean is, in fact, a mathematical ratio. By definition, this age-old theory suggests that the best division of a line is such that the ratio of the shorter part to the longer part equals the ratio of the longer part to the entire line. I call this the 3:5 ratio, based on dividing that line into eight sections.

We see examples of the Golden Mean all around us in nature, and our eyes are instantly attracted to them. Perhaps this is due to the fact that the human body contains many Golden Mean divisions and that the beauty we admire stems from our appreciation of our own form. For example, examine the bones in your hand: The finger bones up to the wrist bone all equal a roughly 3:5 ratio for a total count of eight. The length of the end bone of your finger, from joint to tip, would more or less equal three; the length from that joint to the next one down—the second bone—would equal five. Then this second bone becomes three and the next bone equals five, and so on. Many of the body's divisions and arrangements including facial features, internal organs, and even the location of the navel fall into Golden Mean ratios.

These unequal space divisions in nature can be used consciously within our paintings for pleasing effects.

Use Approximate Uneven Ratios for Attractive Space Division
I try to use the 3:5 ratio as often as possible in a painting, but if the subject does not conform exactly to this relationship, I don't worry about it. As long as each shape measures somewhat differently, that is enough to please the eye. Unequal space divisions were inherent in this close-up view of a steam engine train.

Steam Era ~ Transparent watercolor ~ 21" x 28" (53cm x 71cm) ~ Collection of the artist

The History of the Golden Mean

It has been proven that the human eye responds sympathetically to certain shapes and arrangements which correspond to measurement, proportion and harmony. Does it surprise us then that the ancient Golden Mean proportions in art continue to please us? Paintings, architecture and other arts that are beautiful through their systems of measurements satisfy something spiritual in our human natures. Many of us forget that we have a basic and continuous need for emotional, intellectual and spiritual growth in order to achieve true self-fulfillment.

The Golden Mean appears as the central design principle in much of the great art and architecture of the past. This proportion shows up again and again as we look at the Parthenon in Athens, the cathedrals Notre Dame and Chartres, and even the great pyramids of Egypt. It appears in many of the paintings of Botticelli, Raphael, da Vinci and countless other masters. Despite all this history of the Golden Mean's use in art, many art students are unfamiliar with it. It seems strange that something so basic to beauty in art is rarely discussed. This chapter intends to awaken your awareness of this great ratio and your abilities to use it in your own work.

I regularly use Golden Mean calipers to show my students how to create eye-pleasing space divisions in their work.

A pair of calipers showing the 3:5 ratio.

Everyday Appearances of the Golden Mean
A nautilus shell, the Notre Dame and the bones of the human hand are only a few examples of the many 3:5 ratios present in our world.

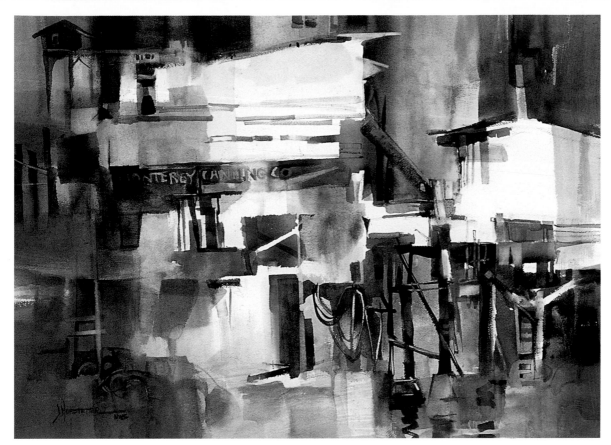

How Many Approximate Golden Mean Ratios Can You Find in This Painting?

All measurements in art certainly don't have to be of Golden Mean proportion, but once artists begin to see the beauty of these ratios, then this division seems to show up more frequently and makes the work more beautiful. See how many loose Golden Mean space divisions you can find in this painting.

Wharfwood #1 ~ Transparent watercolor ~ 21" x 29" (53cm x 74cm) ~ Collection of the Palo Alto Medical Foundation

Found Ratios

Here are some of the ratios I found. Also note that the outside measurements around the focal area are close to the Golden Mean as well, from top to bottom and side to side. If the painting is well designed, Golden Mean ratios will probably show up in the focal area as well.

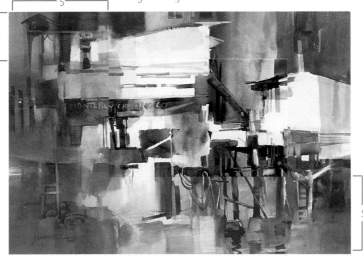

Practical Ways to Apply the Golden Mean

Look back at the paintings in this book and you will discover that many use the Golden Mean to divide the subject matter within them or to break up the edges. This doesn't mean you have to use a ruler to plan all of your paintings. Generally, you can arrive at your proportions without strict ruler measurements. Measure with your eyes using a relaxed generalization of the ratios. After awhile, using the Golden Mean becomes instinctive—thank goodness!—so you can move beyond mathematics and indulge your creative side.

There are many practical ways to apply the Golden Mean in your work. Let's look at a few examples.

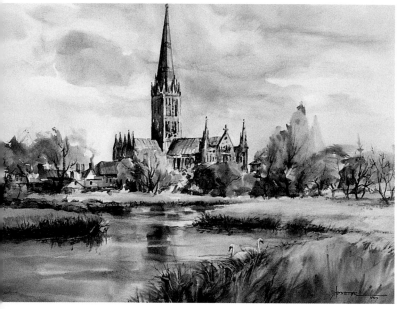

Break Up a Dominant Horizontal With a Well-Placed Vertical
When a painting has a vertical movement or shape against a horizontal one, use the Golden Mean to determine the point where the shapes will cross. In this painting, I made use of the tallest vertical—the cathedral tower—by using the 3:5 ratio to break up the horizontally dominant landscape.

Salisbury Cathedral ~ *Transparent watercolor* ~ *18" x 24" (46cm x 61cm)* ~ *Private collection*

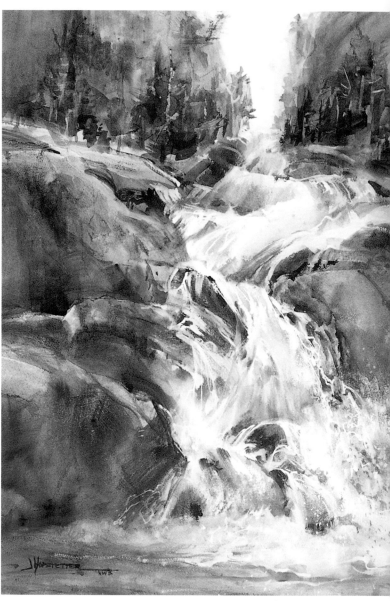

Break Up a Dominant Vertical With Multiple Horizontals
With the sky and water creating a strong, light vertical path, it is necessary to slow down this movement with horizontal patterns of light falling on the shoulders of the rocks.

Dancing Waters ~ *Watercolor and graphic white* ~ *29" x 21" (74cm x 53cm)* ~ *Collection of the artist*

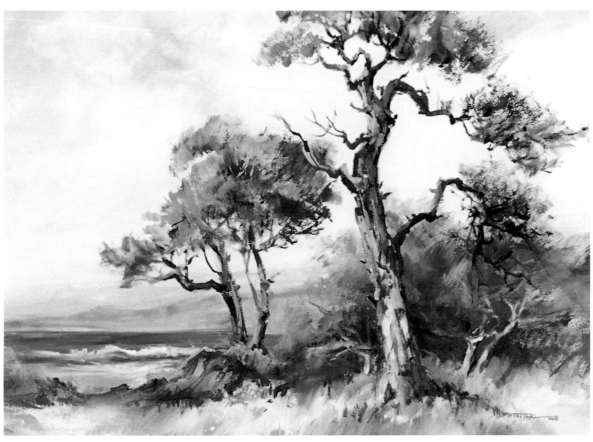

Placing Natural Elements Using Ratios

Trees can divide a horizontal landscape into a number of Golden Mean ratios. If the focal tree is the first division, then each of the two created spaces can also be divided with trees in a 3:5 ratio and so on for as many trees as you wish. You will find that the resulting space between every tree is always a different size, as these spaces should always be, to please the eye.

Monterey Pines ~ Watercolor and graphic white ~ 21" x 28" (53cm x 71cm) ~ Collection of the artist

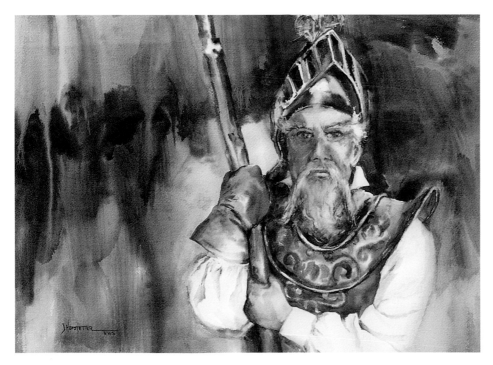

Applying the Golden Mean to a Portrait

A portrait works well in a horizontal format if the eyes divide the rectangle into a 3:5 ratio vertically as well as horizontally.

Don Quixote ~ Transparent watercolor ~ 21" x 28" (53cm x 71cm) ~ Collection of Dr. Dave R. Hofstetter

Practice Breaking Up Space

Let's combine good placement of focal area and division of space in paintings using the Golden Mean to plan an attractive composition for this desert scene.

Reference Photo
This interesting rock formation in Sedona, Arizona, is a popular subject for painters because of its naturally irregular pattern—an obvious choice for placement within the focal area.

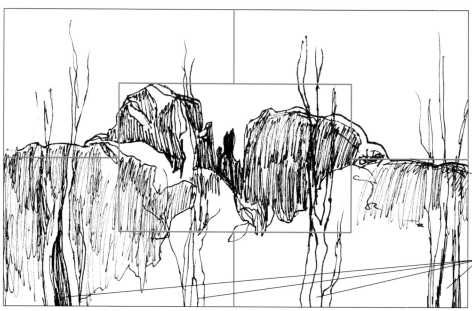

Equal Space Divisions
When the focal area is placed in the dead center of a composition, it acts as a magnet: The eyes go there first and are trapped. They do not naturally travel to the rest of the areas in the painting. The equal space divisions within this sketch make the viewer lose interest quickly.

Poorly placed horizon line divides painting into equal halves

Equal, boring spacing between the trees, which are too similar

Unequal Space Divisions
Remember the eye of the focal area we talked about in chapter three? In this sketch we want the eye of the rectangle to be where the most interesting rock piece is located, so we shift the focal area along the diagonal line from the lower-left corner to the upper-right corner until the eye and the rock piece meet. This focal area falls within a Golden Mean division.

Notice how many 3:5 ratios are at work here. Also, the irregular diagonal trees repeat some of the diagonals in the focal area for a feeling of unity.

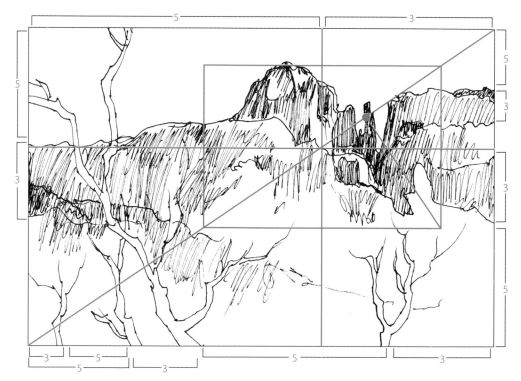

Seek Ways to Improve Your Subject With Golden Mean Divisions

While many of nature's designs seem miraculously perfect, its patterns of light and dark are not always arranged perfectly for a painting. These patterns change constantly during the day as the sunlight changes. After awhile, artists don't spend a lot of time chasing down the perfect light on a subject as a photographer must. Artists can manipulate what they see in photos to find more interesting patterns of light and dark. The viewer will believe anything the artist paints if it is interesting and beautiful enough.

Let's take a beautiful scene and improve upon it for a more interesting painting plan. Consider Golden Mean space divisions as well as focal area placement, value contrast, shape arrangement and other ways of strengthening a painting for the ultimate impact.

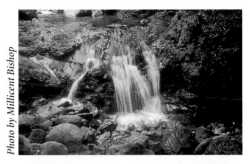

Photo by Millicent Bishop

Reference Photo
Rushing water is captured beautifully in this photo.

Close-Up Shot
Here is a close-up view of the lovely waterfall, which will make the subject even more dramatic. There are often suggested geometric shapes of triangles, rectangles or half-circles in natural landscapes. Such shapes can be made more irregular, and therefore more beautiful to the eye, for a finished painting. Locate some of those shapes that can be changed in the photo, especially within the focal area.

Photo by Millicent Bishop

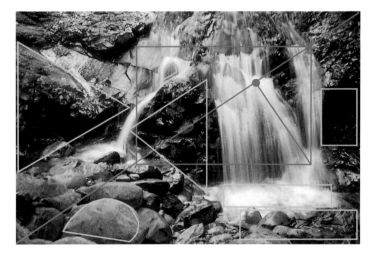

Identify the Geometric Shapes and the Eye of the Rectangle

The focal area is in the upper right, and the eye of the rectangle is where the most action is—the greatest amount of water cascading over the rocks. There are quite a few geometric shapes in the overall scene that can be softened or adjusted for the final painting.

Apply the Golden Mean and Soften the Geometric Shapes

When in doubt of how to break up a boring shape, use approximate 3:5 ratios to divide it. You can also vary the shapes by adding irregular edges. The focal area is emphasized in this final sketch by juxtaposing small pieces of the lightest and darkest values.

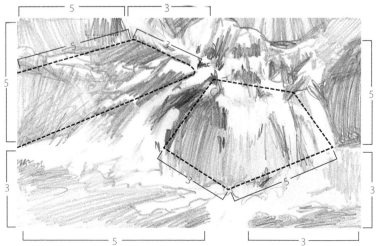

Consider the Best Golden Mean Shapes When You Select a Format

Experiment with your reference photos to discover what format will give you the most exciting painting. Use two L-shaped pieces of paper on top of the photo to crop to the shape you are investigating. Adjust the L-shaped mats until they show the most irregular shapes possible in the photo. Look for big, medium and small dark and light shapes. Find the focal area and the eye of the rectangle. Make the focal area where the most exciting pattern exists.

After you experiment with the different croppings, choose the orientation you prefer (square, vertical or horizontal). Chances are it will be the one that contains the most 3:5 ratios. Of course, you could always rearrange the elements of your reference photo to achieve these ratios in whatever format you want.

It is not always possible to find perfect 3:5 ratios in the shapes you are working with, but just knowing about the Golden Mean will bring you closer to creating a very pleasing composition.

Photo by Millicent Bishop

Reference Photo
This handsome flower photo contains beautiful warm to cool colors in the petals. We'll crop this photo into three different formats to decide which one has the best focal area and 3:5 ratios.

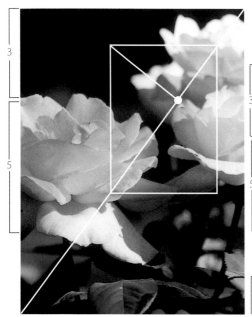

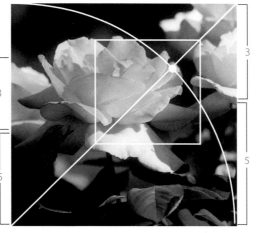

Square Format
With the square format, the focal area takes the form of a square. The eye of the focal area is found where the diagonal line meets the arc created by using one side of the square as a radius. Using a compass will give this placement.

This arrangement has two 3:5 ratios on the edges, which is a better design than the vertical format.

Vertical Format
See if you can create an exciting vertical composition. Find the vertical focal area as well as the eye of the rectangle. I was not pleased with this arrangement, which shows only one 3:5 ratio on its edge. It would be better with more.

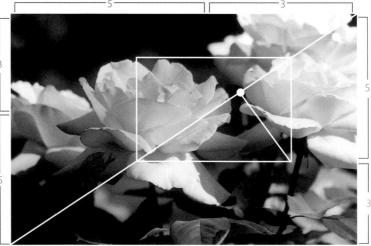

Horizontal Format
Now try a horizontal composition. This arrangement is the best one because it contains the most 3:5 ratios on the edges.

SUMMING UP *the Golden Mean*

Follow these tips to achieve beautiful 3:5 ratios in your paintings as you get comfortable working with the Golden Mean. Later it will become mostly instinctive and you will use more generalizations of the ratios.

- Divide each of the four sides of your paper into eight equal parts using light pencil marks on the edges. This will help you clearly see how you are dividing the space for your painting.

- Count down three spaces for a high horizon line or five spaces for a low one.

- Count across three or five spaces along the top of the paper and place the tallest vertical there.

- Identify the halfway point of each side of your paper and avoid letting things stop or start there, which creates perfectly equal divisions that are uninteresting.

- Place trees, flowers or other repeated subject material at 3:5 ratios so that all the subjects are differently spaced. Make the groupings a ratio of 3:5 in size as well.

- A well-designed painting will have 3:5 ratios not only around the edges of the painting but within the focal area.

- Use 3:5 ratios to help you soften unpleasant geometric shapes.

- When choosing a format for your painting—horizontal, vertical or square—consider which one will give you the most 3:5 ratios.

- Exact 3:5 ratios are not absolutely necessary; just aim for unequal space divisions.

Golden Mean Usage in a Horizontal Format
This is the format I chose for the rose painting. Notice how I used a lot of color, contrast and irregularity to make the focal area shine in the final painting.

Millicent's Roses ~ *Transparent watercolor* ~ *21" x 28" (53cm x 71cm)* ~ *Collection of the artist*

7 *Emotional Depth*

Lastly look in your heart
And paint what you see,
Then remembered forever
Your painting will be.

The ideas in the previous chapters were initially compared to part of the human body. I like to think of this last chapter as relating to the body's invisible artistic spirit or soul. After you learn and digest the basics in art, give yourself the reward of creating a painting that bursts from something inside and paint it with all the emotion you can muster toward the subject.

Magic comes to art when we succeed in describing our emotional depth in a visually creative way.

The more we become acquainted with art that has endured for a long time, the more we begin to see and appreciate the importance of feeling in painting. This quality of spirit or passion the artist puts into a painting lies beyond skill alone and is perhaps indefinable, yet the viewer will always see it as extremely authentic. Perhaps this quality is what makes a "forever painting," one that will be remembered forever by all who see it.

What eventually becomes the most important thing to us as we critique our collection of work is not the subject and what we do with it intellectually or technically—although that is always important—but how we describe visually our strong feelings about it. Unfortunately there is no magic formula to make passion appear in a painting, just as there is no magic formula for putting in one's innate originality. It is either there or it isn't. Some subjects excite all our senses and others don't. Frequently, emotional depth enters our work when we take the time to figure out what we really love the most about the material, and simply hang onto that thought as we create the painting.

Paint What You Love
Let your spirit lead you to the subject you paint. I simply adore hollyhocks!

Hollyhocks ~ Transparent watercolor ~ 21" x 29" (53cm x 74cm) ~ Collection of Diane and Lee Brandenburg

Paint What Excites You

What makes you go, "Wow!" every time you see it? Paint that. What nearly makes you weep because of its intense beauty or sadness? Paint that. What would show up in your fantasy if you walked right now through a mysterious doorway? Paint that, and then paint it again. Painting is more than just making pleasant pictures. It is participating in the wish to share visually all of our most intense feelings. Strong feelings or passion toward a subject cannot and should not be hidden as we paint.

By giving a painting a strong emotional charge, you give it the single most powerful and creative thing possible. Let's look at some examples of ways to accomplish this.

A Picture Worth a Thousand Words

Start with a terrific title or a few lines of favorite poetry and then do a painting of that subject. The title *Sculldrudgery* came to me as I watched my nephew hard at work with his college crew team. I took my reference photo from a bridge as the crew practiced below.

Incidentally, when this painting won an award in a national show, the judge said that the work was timeless until one saw the green sneakers!

Sculldrudgery ~ Transparent watercolor ~ 21" x 29" (53cm x 74cm) ~ Collection of Claudia Vickers

Let Your Subconscious Mind Emerge

Use a dream or fantasy to make a mystical painting. You can superimpose a face or figure over a landscape. Line extension added to it works well also. In *Stonehenge*, the eyes showed up when I accidentally spilled paint during a demo, and I then let the face keep emerging as I painted. My children won't let me sell this one!

Stonehenge ~ Transparent watercolor ~ 25" x 40" (64cm x 102cm) ~ Collection of the artist

Discover the Background of Your Subject

Learn the history of an exciting subject, and feel it as you paint it on location. This always helps to develop a strong sense of place. A class member of my workshop read aloud this castle's history as I painted it.

Scotney Castle ~ Transparent watercolor ~ 21" x 28" (53cm x 71cm) ~ Collection of Diane and Lee Brandenburg

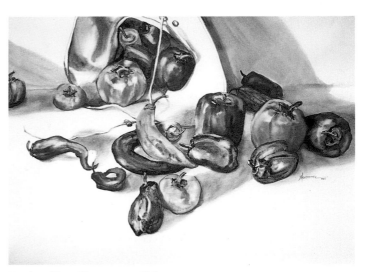

Be Inspired by Mother Nature

Use exciting weather, different seasons or a certain time of day to enhance your feelings toward a favorite place, and paint it many times. Lighthouses fascinate me as wonderful subject material. There is an exciting interplay between the forces of nature and man's striving for safety against constantly changing weather conditions. For this painting I wanted to show the early importance of this lighthouse, not just have it sitting idly on a golf course as it does today.

Prevailing Wind ~ *Transparent watercolor* ~ *21" x 28" (53cm x 71cm)* ~ *Collection of the artist*

Explore Your Humorous Side

What tickles your sense of humor about a certain subject? Can you bring out a bit more of this in the painting? The title, a play on words, is perfect for this painting of my garden hat filled up with homegrown hot peppers.

Hat Peppers ~ *Transparent watercolor* ~ *21" x 29" (53cm x 74cm)* ~ *Private collection*

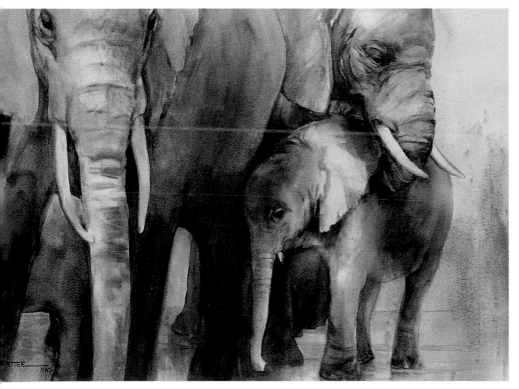

Portray a Struggle or Plight

If you feel great sadness in the struggles or plights of certain people or animals, speak about this in your painting. For instance, the elephants are being crowded off our planet. This painting implies just how few areas are left open to them.

Endangered Species ~ *Transparent watercolor* ~ *21" x 28" (53cm x 71cm)* ~ *Collection of Dr. Julia Lewis*

Paint a Series

Three questions may crop up when you feel like creating a series of paintings on a subject that touches you emotionally. They are:

- Do I love this subject material so much that I could paint it forever?

- Do I wish to deeply get to really know this material better by painting it many times?

- What personal painting challenges can I grow from by constantly changing various viewpoints on the subject's color, value shapes, design structure, etc.?

If you answer these questions with positive answers and can't wait to get started, you should enjoy doing a series of one subject. I like to save the whole group of paintings whenever possible and select the best to enter in competitions. Be prepared to learn a lot about yourself as an artist and about the subject itself as well. Also, make sure that you quit the series before you get tired of it!

I loved sketching and then later painting a series on San Francisco's drifting fog. I have often seen the city from a boat, and I've admired its beauty all my life. From this has grown a deep love affair. Here are some of the paintings of San Francisco I did as demonstrations for my students.

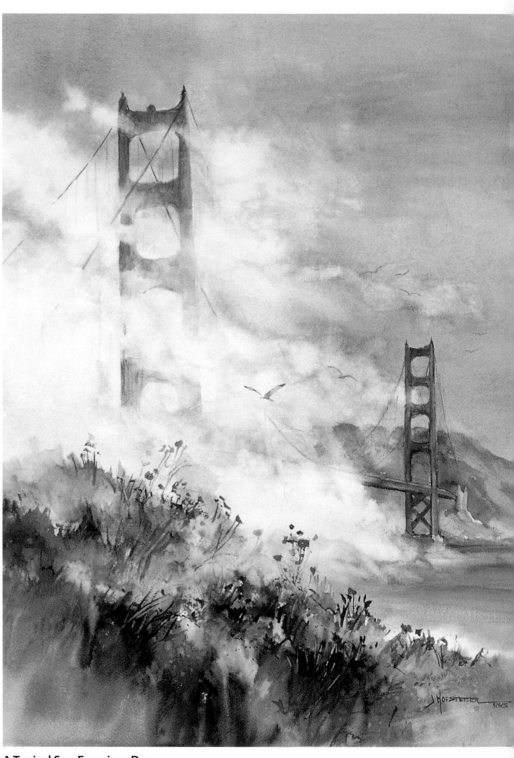

A Typical San Francisco Day
Mist or fog always adds mood to a painting. This is often the signature of San Francisco, as is the majestic Golden Gate Bridge, shown here from a viewpoint that reveals its vastness.

Golden Gate, Drifting Fog ~ Transparent watercolor ~ 28" x 21" (71cm x 53cm) ~ Collection of Bill and Shirley James

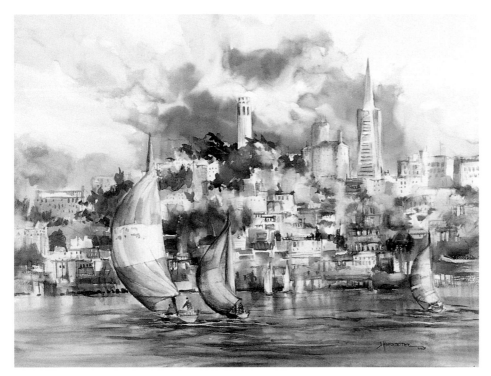

A Panoramic View

In this view of the city, the veil of fog is lifting to reveal a bustling metropolis, the focus of the painting. The passing boats with their billowing sails reinforce the windy day.

Bay Fog #2 ~ *Transparent watercolor* ~ *21" x 28" (53cm x 71cm)* ~ *Collection of Mary Lou Cline*

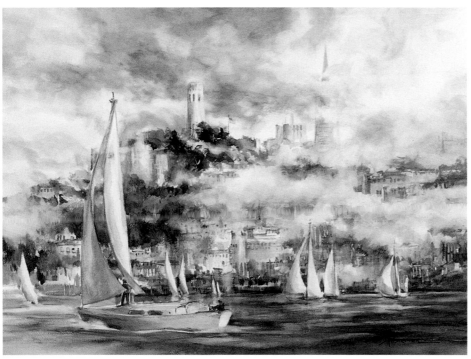

Panoramic View, Different Focus

In this painting the fog descends upon the city once again. Between the visible fog and deflated sails of the passing boats, you can sense that this is a far less windy day. The focus here is less on the city and more on the action in the bay.

Bay Fog #4 ~ *Transparent watercolor* ~ *21" x 28" (53cm x 71cm)* ~ *Collection of Bill and Shirley James*

Have Fun With Abstract Painting

I enjoy making a few abstract paintings after painting a group of tighter representational paintings. What fun it is to create chaos on a piece of paper and then use the design principles to bring some order to it, not knowing what the final result will be.

Sometimes faces, figures or even your own personal symbols show up in this type of artwork if you look for them. I never know in advance what I will be painting, but I typically start out by having my students give me a dominant color and an abstract value pattern to use as an underpainting. I begin by laying in the pattern for the first shapes—which could be one of the patterns from page 16—then I look for unexpected elements to emerge as the painting progresses.

For this painting, the class wanted red to be dominant. With heavy paper taped around the edges to a board, I was set to go. To fuel my creativity I kept on hand some collage materials and some matte medium to adhere them with. I often use gouache colors as well as water-soluble crayons or other markers—as long as I have tested them and they are nonfading—for additional variety.

Moving the Paint With A Lot of Water
I first wet the paper and, using assorted reds with some light cools for contrast, began an abstract underpainting of the pattern chosen. Enjoying the freedom to play, I splattered and sprayed water into the paint, turning the board and letting gravity take the paint where it would. Remember, you can't hide anything in a painting, so a sense of fun and play as you paint shows.

Dry It to See What's There
When the pattern looked interesting, I dried it quickly with a hair dryer so we could take a good look. The class found what appeared to be a small figure in the upper right of the painting. That became the focal area, and the rest of the painting related in some way to that figure.

Value Pattern
The value pattern chosen by the class.

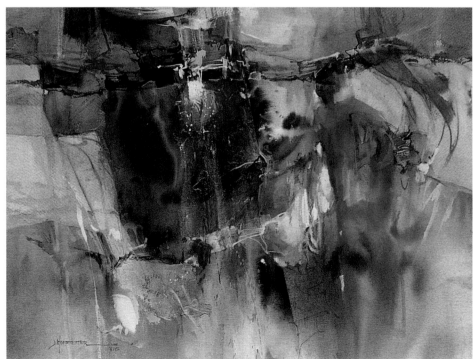

The Finish
I brought out some soft facial features on the figure. I continued to work on the big, medium and small shapes for variety, with lots of texture and color searching. I added some prepainted tissues as collage in a few places and used graphic white and water-soluble crayons in areas.

Much of the painting seemed to take on the texture of loosely woven cloth, and as the figure seemed to be moving a little, the class wanted to call the work *Dream Weaver*.

Dream Weaver ~ *Mixed watermedia and collage* ~ *21" x 28" (53cm x 71cm)* ~ *Private collection*

Paint From Strong Feelings—Even Negative Ones

The emotion you paint from doesn't have to be happiness. What if your feelings come from the intense trauma of a disaster?

On September 11, 2001, I was teaching a weeklong workshop for a watercolor society in Los Angeles. When I awoke that morning and saw on my television the terrorist events happening in New York, Pennsylvania and Washington, D.C., I wondered if any of my students would be at class that day. Although we were all dealing with shock and horror, the entire class was present. Many had brought cell phones, and some were in tears, but they had all come.

What a day that was, and how fortunate we all were to be able to paint some of our emotions out. I had goosebumps and my voice shook as I talked about their paintings at critique time. Such powerful, beautiful work—to be "forever remembered"— came out of our response to those shocking events that day. We painted somewhat abstractly and stayed flexible enough to transform a negative situation into positive art statements.

All artists can choose to use life's emotional wallops this way. The work done that day could have become an impressive, energy-packed art exhibit. Shown on this page is the demonstration painting I did that day, but the students' work was overwhelming.

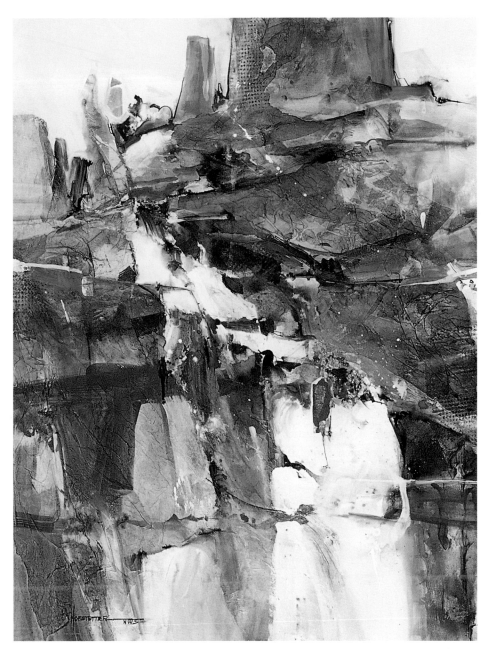

Desolation ～ *Watercolor, graphic white and collage* ·· *28" x 21" (71cm x 53cm)* ～ *Collection of the artist*

Painting Accidents Can Work for You

Students tell me that the fluid medium of watercolor is often unpredictable. Strange things that other mediums don't necessarily experience can happen with this wet paint. I like to demonstrate somewhat vertically so that the class can see what is going on, and I often use different spray bottles to move the paint around on my paper.

This use of the pull of gravity, along with water sprayed into fresh paint, is always exciting yet a little tricky to handle. The painting must be turned around often to keep the paint from running too much, and it must be laid down flat at the proper time. Sometimes a student asks a question as this process is taking place, and if I take the time to answer it, strange things can happen to the paint.

Such was the case in this iris painting done for the class. After painting the backlit flowers, I painted the background using complementary colors and then sprayed water into the wet paint. The painting was upside down as I stopped to answer a question, and when I looked back at it again, a strange colored streak had appeared. Flames seemed to come out of the flowers.

Sometimes these unplanned accidents can give your work more emotional depth. Try to use them if you can. *Secret Flame* became the name of this painting.

Secret Flame ~ *Transparent watercolor* ~ *28" x 21" (71cm x 53cm)* ~ *Private collection*

LANDSCAPE, REALISTIC VERSION

MATERIALS

SURFACE
- 300-lb. (640gsm) rough watercolor paper

WATERCOLORS
- **Transparent colors:** Blue Green, Carbazole Violet, Cobalt Blue Tint, Indanthrone Blue, Indian Yellow, Orange Lake, Permanent Magenta, Permanent Rose, Rose Dore, Sap Green
- **Transparent earth colors:** Permanent Brown, Quinacridone Burnt Orange, Quinacridone Coral, Quinacridone Gold, Quinacridone Sienna
- **Opaque/sedimentary colors:** Cadmium Orange, Cobalt Blue, Cobalt Teal Blue, Scarlet Lake

BRUSHES
- **Flats:** 1½-inch (38mm), 1-inch (25mm), ½-inch (12mm) and ¼-inch (6mm)
- **Rounds:** nos. 1, 5, 8 and 12

OTHER
- Silver pencil and white plastic eraser
- Sponge
- Graphic white

A saying goes, "Creativity is at its best when the concepts are crystal clear and the limitations are most severe." I believe that when we paint within a narrowed framework of a subject that speaks to the heart, our creativity is endless. Here is one of my favorite subjects, the red rocks of Sedona; let's see how creative I can be painting their rich collection of colors in a traditional way.

My goal is to paint the color that falls on Cathedral Rock late in the day. My reference photo doesn't begin to capture the brilliance of all those colors I remember, so I will paint somewhat from memory and my feelings, trying to make them more intense.

A dramatic color scheme is a must to make the scene come alive. Red-orange will be dominant and accompanied by all the earth colors. Then red-violet, red, orange, and yellow-orange will be included, along with three complements—blue, blue-green and green. Intense yellow, yellow-green, violet and blue-violet will not be used. I will constantly color search the twelve darker background colors also.

PRACTICE INTEGRITY OF PLANE
Remember that when painting realistically, each plane needs its own individual grouping of colors to give depth to your work. In other words, colors should not exactly repeat from background to middle ground to foreground.

Reference Photo

Value Pattern
The focal area will be in the upper left. We'll place the smaller, most exciting shape arrangement in this area.

1. Make a Drawing and Begin the Rocks

Draw a pencil outline of the subject on the paper. Use a wet sponge to remove some of the sizing from the paper, and let the paper dry for the most part before you start painting. With warm earth colors, paint the light parts of the back rocks first, constantly searching for color changes in the light values.

2. Start Adding Darks to the Rocks

As you paint the darks of the rocks, keep in mind that twelve different darks on the color wheel can be used. Warm darks look good against cool darks, and constant color change always pleases the eye. Add rich, dark reds, browns, blue-greens, dark oranges and purples; try to go no farther than an inch (3cm) without changing a color or value. At this point I paint more from my feelings and memories of the subject than what I see in the photo of the rocks.

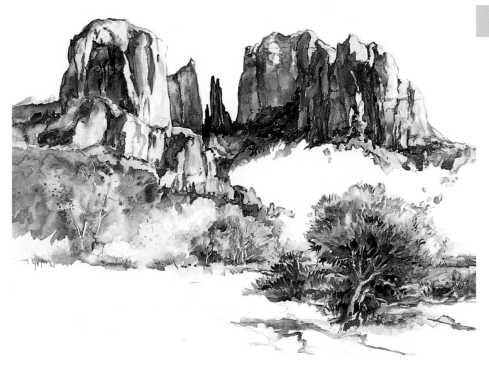

3. Finish the Rocks and Move Toward the Foreground

Finish the background rocks, keeping the sunlight coming from the upper right consistent in the painting. Develop a cool foreground to better play up the warm focal area rocks. Color search the cools in the main foreground bush, applying various blues, blue-greens, greens and violets with neutral or grayed earth tones, as all is in shadow. Leave reality and paint what the area *should* look like rather than what you see.

After painting the bush, paint the area just below the rocks, constantly trying to change colors, values and textures for visual interest. Make the lights and shadows correct for the sun's location.

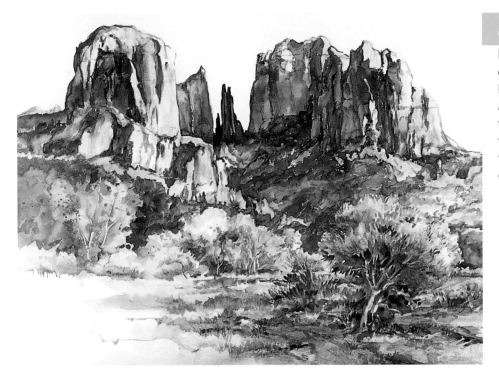

4 Continue the Middle Ground and Foreground

Finish painting the cool, shadowed foreground. Gradually add warmer color as the land transitions into the middle ground and back to the base of the cliffs, where the light hits in the distance. Notice how the greens change from the foreground to the middle ground. Play warm against cool, complement against complement.

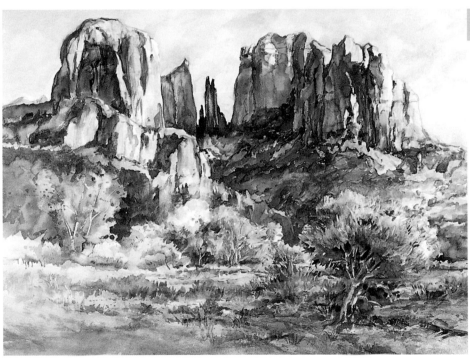

5 Paint the Sky and Final Details

I decided to keep the sky light against the top rocks for dramatic contrast. Mix some graphic white with your various blues, and use these pale colors to paint the sky. Do the same thing with your warm colors, mixing several pale versions, and add them to the sky for a contrasting-temperature effect.

Because of the use of opaque colors for the sky, add a few more opaque lights to the rest of the painting for a more consistent look. Notice how the light top edges in areas of the foreground, middle ground and background are touched up with light gouache colors.

Cathedral Rock Afternoon ~ Watercolor and graphic white ~ 21" x 29" (53cm x 74cm) ~ Collection of the artist

PAINT THE SKY LAST

It is often a good idea to leave the sky as the last thing painted. This allows you to see what colors it needs to help enhance the rest of the painting. Remember, the sky is the introduction to the rest of your landscape painting.

LANDSCAPE, ABSTRACT VERSION

MATERIALS

SURFACE
- 300-lb. (640gsm) cold-pressed watercolor paper

WATERCOLORS
- **Transparent colors:** Carbazole Violet, Cobalt Blue Tint, Indanthrone Blue, Indian Yellow, Orange Lake, Permanent Magenta, Transparent Yellow
- **Transparent earth colors:** Permanent Brown, Quinacridone Burnt Orange, Quinacridone Coral, Quinacridone Gold, Quinacridone Sienna

BRUSHES
- **Flats:** 1½-inch (38mm), 1-inch (25mm), ½-inch (12mm) and ¼-inch (6mm)
- **Rounds:** nos. 1 and 3

OTHER
- Silver pencil and white plastic eraser
- Plastic stencil
- Fine-mist spray bottle
- Elephant-ear sponges

A strong abstracted painting often has a subject that has been filtered and condensed through the artist's philosophy to its essence, perhaps with some visual poetry thrown in. Good abstracts can arise from strong feelings that translate into convincing truths to the viewer. Often abstracts appear more authentic and are more likely to be "forever remembered" than if the subject was painted in a realistic manner.

Native Americans have said that the Sedona area was "spirit taking form." Long before the "white man" came, this area was where the tribes often met for their sacred ceremonies. Some of the ancient rock petroglyphs in various parts of Arizona perhaps let us glimpse the Native American interpretations of the spirit gods.

Trying to weave some of these ancient, spiritual petroglyph symbols—and Cathedral Rock, the subject of the previous demonstration—into an abstracted, spiritual painting will be exciting. Remember that abstracted work needs all the fundamentals of good design, often more so than realistic work does.

Value Pattern
This was chosen from the page of patterns in chapter one.

Value Pattern With Focal Area Placed
I turned the value plan upside down, enlarged it and then placed the subject material (the rocks) within the focal area (the lower right).

Inspirational Sketches
These are some of my sketches of Native American spirits found in ancient petroglyphs.

1 **Make a Loose Drawing and Set the Stage for a Sunrise**
Draw outlines of the value pattern and rocks on your paper. The color scheme will be predominantly warm, with complementary yellows and violets, to create the mood of early sunrise. Wet the paper thoroughly, and as soon as the sheen has left the paper, begin to paint with a large flat. Leave some white paper behind rocks for a circular sun of about three inches (8cm). Then, starting with Transparent Yellow and working outward with Indian Yellow, Orange Lake, Permanent Magenta and finally Cobalt Blue Tint, paint pale rings of color that fade gently into each other until you reach the outer edges of paper. Let this step dry.

2 **Paint a Rocky Silhouette**
With your large flats, loosely paint the lower rock area and landscape with the sun peeking out from behind it. This should be done in a graduated way as in step 1, placing the warmest rock tones nearest to the sun. Use darker versions of the same colors from step one, and let the colors blend into each other. Let this dry.

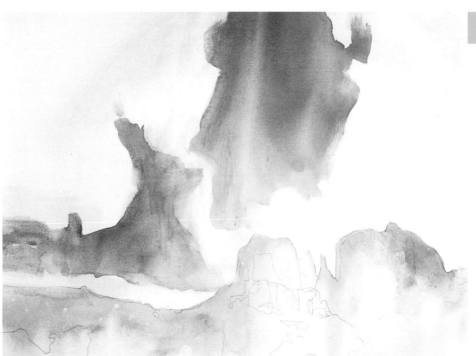

3 **Paint the Clouds**
Place the painting upside down and work on a vertical slant of six inches (15cm) or more. Paint the clouds above the lower landscape in a gradated manner, with the warmest colors nearest the sun and with cooler, grayer, darker colors as you move toward the top of the painting. As the paint begins to lose its sheen but is still wet, spray it gently with the fine-mist spray bottle to get some paint to run a bit. When you are satisfied, lay the painting flat, wipe it around the outside edges, and let it dry.

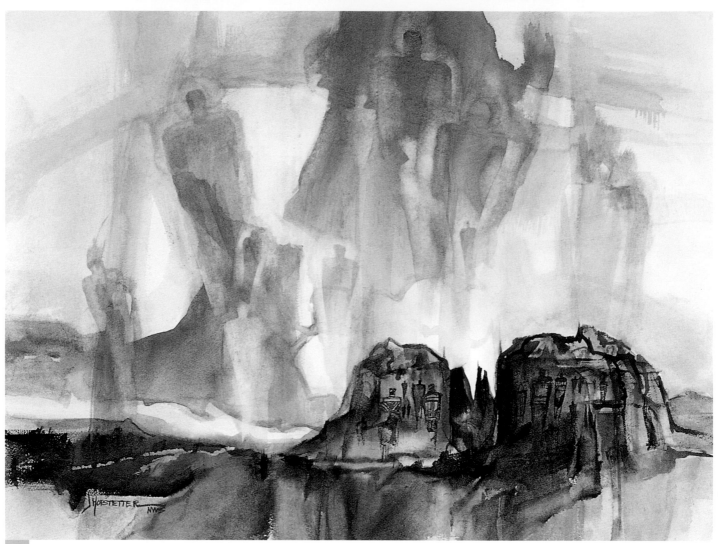

4 Finish With Darkest Darks and Stencil Work

Mix dark magentas and browns with your darkest blues and purples to get a variety of darks. Darken some of the lower landscape, referring to the original value pattern. Loosely paint the rocks with a minimum of detail so that the carvings you add next will show up. When this is dry, refer to the petroglyph sketches and add some of these to the rocks with a small round.

After cutting out several sizes of the petroglyph figures in stencil plastic, lay them down on the sky area. Lightly wash on some pale sky colors—in wide strokes in a few places with a large flat—so that the stencils will show up when this is dry. Then lift off the figures with clean, damp sponges, gradually fading out the edges. Use both the inside and the outside of the stencils, softening various edges for some added mystery. Lightly paint some of the figures for variety, using a flat brush or a damp sponge dipped in paint and used with a stencil.

Ancient Shadows ~ *Transparent watercolor* ~ *21" x 28" (53cm x 71cm)* ~
Collection of the artist

Stencil Cutouts
Petroglyph shapes like these were used to complete the sky in step four.

Emotional Depth

Perhaps the best way to evaluate the emotional depth in your work is to offer yourself a gentle critique. Here are some tips for evaluating your work in a constructive way and using what you learn:

- **Be kind when critiquing your work; the intent is to strengthen your artistic growth.** Learn to praise your efforts by first looking for something positive, even if it is just a pleasing color relationship or a lovely tiny area. See what passages work the best, and compare the weaker areas to those. Weigh both the positive and the negative.

- **Learn from others, but don't punish yourself for being different.** I once had a student who never gave herself a chance. She kept saying her work was terrible compared to someone else's. Try as I would to show her the unique and fine parts of her own work, she rejected it all with self-defeating put-downs. This was very destructive to her artistic growth.

- **Enjoy your successes, but don't let them stifle you.** Another type of growth problem occurred with a student who continued to paint the same type of painting over and over because the first one had once won a top award in a local art show. Acknowledge your successes while daring to try something new each time you paint. You can't grow by staying in the same place.

- **Many times the powerful places in your work can carry the weaker ones.** When I judge an art competition, I find that many of the best paintings aren't perfect but often convey strong ideas to my emotions and my mind even when they are not overly polished or completely spelled out. That being said…

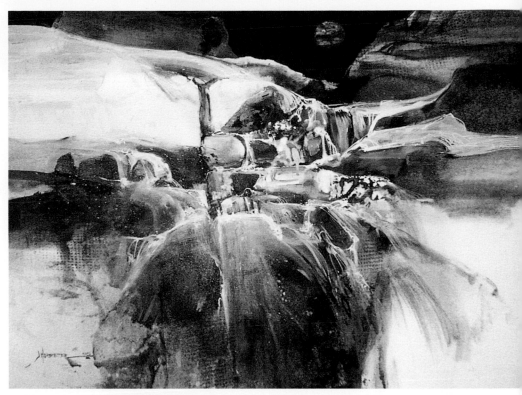

Making a Connection With the Viewer
I created this painting to suggest how the world may have begun—with melting glaciers. The person who bought it told me, "It touched my soul."

Anthology ~ Mixed watermedia ~ 21" x 29" (53cm x 74cm) ~ Collection of Carina Hopkins

- **You can't hide much in a painting.** To a trained eye your work reveals your level of confidence, how skillful your painting techniques are, and whether or not you understand and use the fundamentals of design. Perhaps the most important thing your work shows is the passion or excitement felt as the painting unfolded and became the artist's own original statement. This magic—the beating heart of the work—is part of what makes a painting forever remembered.

- **Subjects that excite you should be explored many times.** Each painting will offer new insights, and as the series grows some wonderful paintings will emerge. Save many of them to occasionally review your new growth, and enter the strongest in exhibitions. However, don't stay with an idea too long after you've had some success with it, because complacency will show in your work.

- **Don't be in too great of a hurry to call a painting finished.** Perhaps six months later you will have gained deeper insights to finally resolve the work's problems.

- **Recognize that each painting is unique.** Good design is important, but often you can break rules and still have an outstanding painting. Painting joy comes with knowing you have succeeded in capturing the mood you felt and showing your own distilled viewpoint. These are the main things to develop as you continue to grow as an artist.

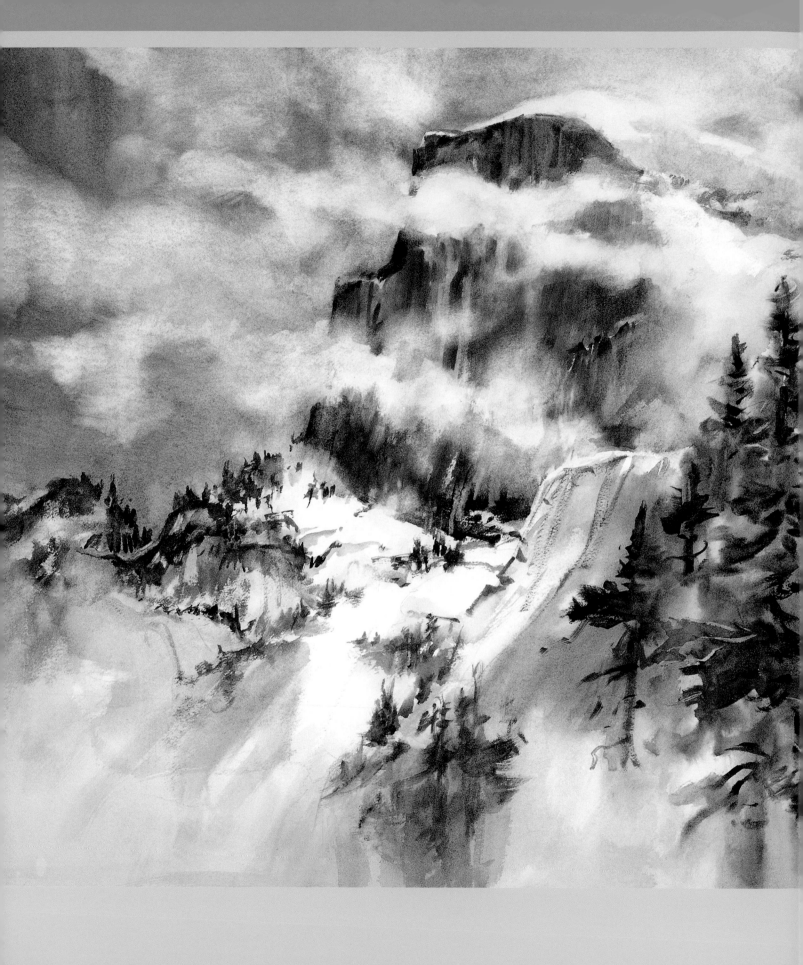

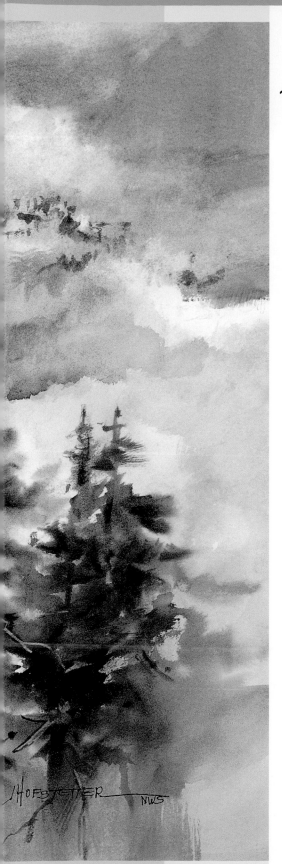

Conclusion

W ell, my artist friends, it is time to sum up everything and meander back to the studio. It will be good to have some time to myself to explore those new horizons that lie ahead in painting. Artists and good teachers must never stop learning.

There is always so much more to say in a book than gets said, and I know there will be many a night I will wake up thinking, "I knew I should have mentioned that!" However, I am glad to have covered all that appears in this book. A lot of terrific inspiration and feedback happens in thirty years of painting and teaching, and I can only hope you now have a sense of those ideas, thoughts and feelings.

Using the human body as a way to describe each chapter's focus might make it easier to remember the various steps that go into great painting. As a visual person, relating to a picture of something in my mind helps me remember things more easily.

The hardest part of painting is starting. Give yourselves the courage and faith to begin, especially when that old fiend "creative procrastination" comes around. It's hard to organize and think *before* we get to the excitement of painting, but without incorporating design knowledge into our work, we run the risk of hit-and-miss results. Many of my students have copied the design questions at the end of chapter five to always use before beginning their work. Some hang the questions by their work space to refer to as they continue painting. This sheet helps them remember all those design principles. After a while, though, these principles become digested, and everything becomes more instinctive.

I am so very grateful that I am an artist. What joy it is to be able to work by expressing the way I see and feel this beautiful world, and to have later a tangible piece of the evidence of my creation. To me this is truly the greatest of all possible lives.

Misty Half Dome ~ Transparent watercolor ~ 21" x 28" (53cm x 71cm) ~ Collection of the artist

Index

Abstract painting, 69, 114, 120-122

Backgrounds, 29, 34, 45-46, 74, 117-118
Balance, 15, 78, 85, 87, 97
Birds, 18, 33-35, 44, 48, 69
Blossoms, 33-35, 45
Boats, 87, 110, 113
Bridges, 80, 84, 112
Bridging, 91
Brushes, 10-11, 24, 58
Buildings, 17, 66-67, 70, 83, 85-86

Castles, 36-38, 110
Cellophane, colored, 21, 24
Center of interest, 15
 See also Focal points
Clouds, 121
Colors
 analogous, 63
 choosing, 65
 earth, 10-11, 22, 36, 50, 94-95, 117, 120
 laying out, 10, 56
 mixing, 10, 57
 opaque, 10-11, 36, 56, 117
 permanent, 58
 primary, 57
 secondary, 57
 sedimentary, 10-11, 56
 tertiary, 57
 transparent, 10-11, 14, 22, 33, 36, 50, 56, 94, 117, 120
 See also Gouache
Color schemes
 analogous, expanded, 59, 63
 analogous, limited, 59, 63-66, 71-72
 choosing, 60-63, 75
 cool, 20, 23, 51
 dramatic, 67, 83, 117-119
 essential, 59-63
 foolproof, 64-65
 lively, 67
 monochromatic, 59-60
 triadic, 59, 62
 understated, 67
 warm, 20, 121
Color schemes, complementary, 55, 59-60, 73
 double, 59, 61
 semitriadic, , 59, 62
 split, 59, 61, 68
Color searching, 57, 66, 69-70, 75
 backgrounds, 117-118
 foregrounds, 118

Color temperature, 20, 23, 29, 37, 39, 57-59, 61-62, 75, 84, 86, 118-119, 121
Color, using, 9, 28, 55-75, 78, 80
 gradated, 31
 local, 55, 58, 60, 68
 natural versus interpretive, 68-69
 for passage, 27, 32
 problems and solutions, 70-75
 reflected, 51, 75
 repetition of, 29-31, 34
 variety, 29-30
Color wheel, 9, 44, 57
Compositions
 evaluating, 97
 organizing, 91
Compositions, arrangements for, 88-90
 axial hold, 89, 93-94
 cantilever, 77, 90, 92, 97
 choosing, 92
 combining, 97
 cruciform, 89, 92
 horizontal, 88, 92
 radial, 90, 93-97
 vertical, 88, 93
 See also Format, selecting a
Conflict, 78, 83, 86-87, 97

Depth, emotional, creating, 9, 109-123
 in landscapes, 117-122
 in a series, 112-113
Depth, emotion, creating, influences for
 accidents, 116
 color, 117-119
 feelings, 115, 117
 subject matter, 110-111
 symbols, 120-122
Depth, visual, 29, 69, 87, 90
Design, 77-97
Design, elements of, 29, 78-82, 86
 See also Colors; Direction, Line; Shapes; Size; Texture; Value
Design, principles of, 78, 83-87, 125
 balance, 15, 78, 85, 87
 conflict, 78, 83, 86-87, 97
 dominance, 15, 78, 84-86 (*see also* Dominance)
 gradation, 78, 85-87 (*see also* Gradation)
 movement, 78, 85 (*see also* Eye movement, directing)
 repetition, 15, 29-33, 39, 78, 84, 86-87, 97
 unity, 78, 83, 86, 104
 variety, 15, 78, 84, 86-87

Details, adding, 10, 24
Direction, 28-29, 78, 81, 84, 86
Dominance, 78, 84
 color, 55, 61, 64, 68, 75, 80, 87 (*see also* Color schemes)
 directional, 81, 86
 line, 81
 shape, 88
 value, 15, 25, 79, 85

Edges
 planning, 97
 recapturing, 24, 38
 soft, 19, 29, 45
 softening, 11, 35, 96
 variety of, 15, 25, 29, 39, 79
Emotion. *See* Depth, emotional
Eye movement, 85, 88
 See also Passage, creating, eye
Eye movement, directing, 13-15, 18, 25, 36, 39, 52-53, 75, 78-79, 86
 through backgrounds, 45
 in cruciform painting, 89
 with lines, 81
 with shapes, 81, 89-91, 94
 with wedging, 91
Eye of the rectangle, 47-48, 50, 53, 104-106

Flowers, 30, 49, 61-62, 67, 74
 composing with, 106
 ginger, 20-21
 hollyhocks, 83, 109
 irises, 65, 116
 placing, 107
 poppies, 22-24, 83
 roses, 107
 See also Blossoms
Focal areas, 9, 14, 41-53
 areas surrounding, 45, 49, 53, 80
 and balance, 85
 choosing, 22, 114
 color in, 42, 44, 69, 72, 75, 80, 88
 contrast in, 53, 79, 88
 establishing, 24, 70-72
 eye of the rectangle in, 47-48, 50, 53, 104-106
 and the Golden Mean, 101
 human figures in, 46-47
 improving, 49, 73
 placing, 42, 53, 60, 88-90, 104, 106, 117
 texture in, 82
 and value, 35, 42-44

Focal points, 47, 49, 53
Foliage, 17, 32, 51, 69, 71, 80, 83, 86
Foregrounds, 29, 45, 91, 118
Format, selecting a, 106-107
 See also Compositions, arrangements for

Glazing, 58, 75
Golden Mean, 9, 99-107
 applying the, 102-105
 applying the, tips for, 107
 and format, 106
 history of the, 100
 and the human body, 99-100
 seeing the, 101
Gouache, 37-38, 46, 56, 119
Gradation, 31, 39, 78-80, 85-87
Graphic white, 11, 37, 114
Grays, 57, 59, 75
Greens, 10

Harmony, creating, 28, 71
Hilltowns, 43, 55
Human figures, 18, 46, 82, 92
 in focal areas, 42, 44, 47, 86, 114
Humor, as inspiration, 111

Inspiration, sources of, 110-111, 120
Integrity of plane, 29, 32, 39, 51, 71, 75, 117
Interlocking, 91

Landscapes, 90, 102-103, 105, 110, 117-122
Lighthouses, 85, 111
Line, 28-31, 38, 78, 80-81, 97
Line extension, 29, 36-39, 110

Masking, 10, 34-35, 95-96
Mistakes, dealing with, 11, 116
Mother Nature, as inspiration, 111

Paint, lifting, 11, 56
Paints, 10
Palettes, painting, 10, 56
Paper, 11, 56
Paper white, saving, 23, 34, 42, 45, 50, 53, 72,
 95-96, 121
Passage, creating, 27-39, 51, 78
 with color, 71
 devices for, 29-32, 39
 exercise for, 28
 eye, 9, 27-29, 31-33, 35-36, 39, 52 (*see also*
 Eye movement, directing)
 good versus bad, 32

in landscapes, 33-35
with line extension, 29, 31, 36-39
white, 19
Pencil, silver, 11, 23
Photos, reference, 21, 33, 49, 65, 104-106
Photos, reference, manipulating, 17, 22, 36, 68,
 74, 94
 color, 71, 73, 117
 format, 106
 shapes, 105
Plight, as inspiration, 111
Portraits, 45, 103

Realism, 69, 117-119
Reflections, 31, 33-34, 71-72, 94-95
Repetition, 15, 29-33, 39, 78, 84, 86-87, 97
Rock formations, 104, 117-122
Rocks, 17, 29-31, 37-38, 48-49, 52, 60, 73, 80-81,
 85, 92-93, 102, 105

Salt, 11, 23
Series, painting a, 112-113, 123
Shadows, color in, 39, 58, 83
Shapes, 28, 78-79, 81, 84
 changing, 29, 105
 in focal areas, 53
 linking, 29, 35, 39
 overlapping, 29, 31, 91
 planning, 97
 repetition of, 29-31, 87
 variety of, 15, 25, 29, 36, 86, 88, 90
 See also Value shapes
Size, 28-29, 32, 35, 78, 80, 84, 90
Sketches, evaluating, 32, 70-72, 97, 104
Skies, 36, 56, 58, 67, 69-70, 72, 83, 90, 93, 95-96,
 102, 119
Space, breaking up, 104, 107
 See also Golden Mean
Spattering, 35
Stencil lifting, 24, 35, 37, 56
Stencils, 11, 122
Subject matter
 anchoring, 91
 choosing, 110-111
 close-up, 45
 emphasizing, with color, 67
 exploring, 67, 123
 history of, discovering the, 110
 improving, 105
 organizing, 17
 placing, 89, 107
 in a series, 112-113, 123

See also by specific subject
Sunrise, 121
Sunsets, 73, 80
Supplies, 10-11, 22, 33, 36, 50, 94, 117
 See also Brushes; Cellophane, colored; Colors; Color wheel; Graphic white; Palettes, painting; Pencil, silver; Salt; Stencils
Symbols, incorporating, 120, 122

Texture, 11, 28-31, 78-79, 81-82, 84, 86, 88, 114
Tints, 57
Titles, painting, 110
Trees, 17, 30, 32, 34, 49-52, 66, 71-72, 82, 86,
 93-97
 diagonal, 104
 leaves, 82, 88
 placing, 103, 107
 reflections of, 94-95

Underpaintings, value pattern, 14, 18-24, 114
 See also Value patterns
Unity, 78, 83, 86, 104

Value, 21, 24, 28-29, 31, 78-79
Value patterns, 9
 evaluating, 36
 examples of, 15-17, 20, 36, 74, 114, 117, 120
 planning, 13-25
 pre-painted, 15, 19-21, 120
 reversing, 17
 seeing, 14, 21
Value shapes, 13-18, 22, 25, 33
Variety, 78, 84
 color, 29-30, 32
 color temperature, 87 (*see also* Color temperature)
 edge, 15, 25, 29, 39, 79
 shape, 15, 25, 29, 36, 86, 88, 90
 size, 32 (*see also* Size)
 See also Design, principles of, variety

Water, 17, 29-30, 32-34, 69-72, 87, 90, 93-97,
 102, 105
Waterfalls, 29-30, 88, 93, 105
Wedging, 91
Wet-into-wet painting, 11, 19, 95

Get more of the best watercolor instruction!

The Watercolorist's Essential Notebook

A treasury of watercolor tricks and techniques discovered through years of painting and experimentation

Gordon MacKenzie

watercolor pour it on!

Let your creativity flow using dramatic color glazing techniques

jan fabian wallake

Painting the Things You Love IN WATERCOLOR

ADELE EARNSHAW

Beautifully illustrated and superbly written, this wonderful guide is perfect for watercolorists of all skill levels! Gordon MacKenzie distills over thirty years of teaching experience into dozens of painting tricks and techniques that cover everything from key concepts, such as composition, color and value, to fine details, including washes, masking and more.

ISBN 0-89134-946-4, HARDCOVER, 144 PAGES, #31443-K

Create startling works of art that glow with color and light! Jan Fabian Wallake shows you how to master special pouring techniques that allow pigments to run free across the paper. There's no need to worry about losing control or making mistakes. Wallake empowers you to trust your instincts and create glazes rich in depth and luminosity.

ISBN 1-58180-487-3, PAPERBACK, 128 PAGES, #32825-K

This gorgeous book shows you how to colorfully combine your favorite nostalgic items like handmade quilts, china and lace with small songbirds or kittens, then bathe them all in beautiful sunlight. You'll find guidelines for developing any heart-warming memory or curious story into a lovely composition. Each step is shown through invaluable mini-demos with finished examples.

ISBN 1-58180-181-5, HARDCOVER, 128 PAGES, #31948-K

Nature paintings are most compelling when juxtaposing carefully textured birds and flowers with soft, evocative backgrounds. Painting such realistic, atmospheric watercolors is easy when artist Susan D. Bourdet takes you under her wing. She'll introduce you to the basics of nature painting, then illuminate the finer points from start to finish, providing invaluable advice and mini-demos throughout.

ISBN 1-58180-458-X, PAPERBACK, 128 PAGES, #32710-K

PAINTING THE Allure of Nature

Susan D. Bourdet

These books and other fine art titles are available from your local art & craft retailer, bookstore, online supplier or by calling 1-800-448-0915.